PURSUIT
AND
PROTECTION
OF
KNOWLEDGE

PURSUIT AND PROTECTION OF KNOWLEDGE

Narinder Attri

authorHOUSE®

AuthorHouse™
1663 Liberty Drive
Bloomington, IN 47403
www.authorhouse.com
Phone: 1-800-839-8640

Published by AuthorHouse 07/25/2012

ISBN: 978-1-4772-5324-3 (sc)
ISBN: 978-1-4772-5323-6 (hc)
ISBN: 978-1-4772-5325-0 (e)

Library of Congress Control Number: 2012913576

ABOUT THE AUTHOR

Narinder S. Attri's professional career spanned over forty years. During this period, he became an engineering professor, a researcher of note, and an author of over forty technical papers including two inventions. He became a pathfinder in the world of aeronautics and astronautics. He served in several Boeing companies starting with the Boeing Commercial Company (Also where he ended) then he continued on to the Boeing Aerospace Company, Boeing Military Airplane Company, and finally, Boeing Advanced Systems. He started the Boeing career as a research engineer and soon became a group leader where he was promoted to becoming a supervisor.

Narinder rapidly rose to become a chief engineer of the mechanical and electrical departments. Five years later he was positioned as the director of all technology departments within the Boeing Military Airplane Company. Then, he became member of the Executive payroll. Five years later he became general manager that was in charge of a division. Ultimately, he led three separate, top secret, divisions of the Boeing Military Airplane and Boeing Advanced Systems. Finally, during the final years he served on special assignments in the Boeing Commercial Airplane Company, to implement an advanced quality system. In his final assignment he led the development of a revolutionary Electrical and Electronic Preferred Process which became basis of Boeing-777 & Boeing-737. They were

the next generation family of Airplanes with a paperless design, build, and support. Now it is in use on all Boeing Commercial Airplanes.

Narinder was appointed as a special advisor to the US Air Force's Aeronautical Systems Division with honorary rank of Lieutenant General. He served in this capacity for twenty-two years. (1972-1994) He was awarded the American Institute of Aeronautics and Astronautics Edward C Wells Award for technical and Management Excellence. "For Developing Team & Technology Leading to a Boeing win on an Advanced Tactical Fighter." Currently the Advanced Tactical Fighter goes by the name F-22 or The Raptor. He served on many technical and industry technical committees, for example the ASME, AIAA, ATA, IATA, and the SAE-A5.

Narinder is married to Indra Attri, a loving and supporting partner. In 2010, they celebrated their 50th anniversary. They have a daughter named Bindu Karen Attri Gerlt and a son named Steve Attri. Bindu is an IT manager at Texas Instruments and has a daughter named Nastasha Gerlt, 18, and a son named Deitrich Gerlt, 16. Steve has two daughters named Marisa Attri, 13, and Sarina Attri, 10 Steve is a Product Manager with Emerson.

Narinder wrote his Autobiography "His Journey-From India to USA"—published by Author House in 2004. "Pursuit and Protection of Knowledge" is a direct result of Narinder's love of God, Family, Friends, and Society. As he says "life is a journey which has only one real destination—to know the "Creator"."

Contents

PREFACE

Without knowledge darkness prevails. God's act of creation was immediately followed by revelation—in other words God's disclosure or manifestation to the creatures of himself and his will.

First known and in greatest detail revelation is recorded in the Vedas. Thousands of years later, revelation became subject of the Christian Bible in Genesis, and hundreds of years later in Quran. These descriptions are very brief and not a satisfactory explanation of creation. This brief narrative was rejected by the scientists at their own peril.

Science has progressed rapidly following Renaissance, a period when revival of arts, literature, and learning in the subjects mathematics, science, and astrology commenced. The catalyst for all this was the discovery of knowledge that was passed on to Greeks, Persians, and later to Arabs by the Indians and by many translations of their treatises into Greek and Arabic.

A brief history of this knowledge both materialistically and spiritually guided Greeks for many centuries, becoming a foundation of their philosophy. The materialistic knowledge laid a foundation for early town planning and the harvesting of water, providing clean water to the population and the storage of water for irrigation. Proper sewage disposal, drainage, storage, and the preservation of food were also undertaken.

The planting of crops required the best growing season of the year and precise calendars. Astrology, engineering, and sciences were propelled by the desire to improve life and were done with the pursuit of spiritual knowledge necessary to balance human desires to the interest of vibrant and responsible societies.

When God created the universe, it was an act of love and super consciousness, providing mankind the most advanced consciousness and all the sensors to transmit and receive the knowledge to carry out its advancement.

The cryptic Revelation as recorded in the Vedas left it up to the Sages to pass on knowledge to ordinary members of society. The humans were encouraged to challenge the Revelation and confirm the validity of revealed matter, and furthermore through this process expand and apply the discovered knowledge to the well being of self, family, society, and the creation at a whole.

Selfish acts that were damaging to family or society were strongly discouraged. The Cosmic Laws were deemed vital and all rewards and punishment were provided by adhering to these laws.

For thousands of years, society lived by these ideas directly gleaned from this knowledge. Later, Prophets essentially summarized what was revealed much earlier to those societies that still lived in dark ages. Much of the material which formed the basis of their religion were tinkered by human-vested interests. Judaism was revised after the return of jewish people who were held in captivity in Egypt and Persia. The Christian Bible was edited and revised for centuries. Many major elements of Revelation were discarded in order to give

churches control over life and death of humans. Islam repeated the history by accepting most of Christian Bible, particularly, the Old Testament.

In Ancient India a code of living was developed that encouraged inquires and discouraged the rejection of other's beliefs. This accelerated the progress but did not prevent other beliefs from emerging. Buddhism and Jainism are both early examples of this. Subsequent to Islam appearing on Indian scene, Bhakti (Devine Worship) movements spread. This led to the belief of Sikhism and a few lesser known beliefs.

Current Hindu practices do not reflect complete adherence to the revelation that forms the subject of the Vedas and Upanishads. Other practices such as the practice of rituals and idol worship also crept in leading to considerable decay. A detailed discussion of these matters is not within the scope of this undertaking.

The purpose of this undertaking was to bring, the true intent of Revelation to the attention of individuals. The pursuit of all forms of knowledge materialistically and spiritually are necessary for a balanced life dedicated to the well being of self, family, society, and the universe. Continuing improvement is envisioned through the dedicated performance of Karma without any desire for reward or selfish gains.

A refocus of society is needed if we are to survive. Many religions have lost their intended purposes, and are now primary reasons for many problems that cause misery worldwide. Readers are cautioned that this offering is *not* a criticism of any religion. Religion is a vast subject by itself. Much is written on all religions and many individuals have their own religious beliefs that are to be respected.

The Revelation in the Vedas reveals that God can be experienced and can serve as a day to day guidance. The knowledge derived from the Vedas has been the basis for all the progress of mankind and it is the treasure for the well being of mankind. The protection of knowledge and its continuing development is our duty in consort with the wishes of God. The Vedas have been challenged by Sages for thousands of years, and just recently have been challenged by scientists too. Up to this day none of the elements of revelation have been proven wrong.

Scientists have expressed utter amazement at the content and its propagation by different techniques. The chapter on consciousness is a primary example. Much of this knowledge came by the revelation and science of spiritual exploration known as Yoga in the West. The depth at which Psychologists have started to study different aspects of consciousness has enhanced the stature of revelation and ancient wisdom.

While compiling the message in each chapter, I have relied on material in English translations of the Vedas, Upanishads, and many other commentaries that were available. I decided on the scope of the material from chapter to chapter, but I do not claim absolute originality in the material contained in the various chapters of this undertaking. All these subjects have been discussed in considerable detail by many authors. My effort in these chapters was to bring to the attention of readers that revelation encouraged and ushered pursuit of knowledge, both materialistically & spiritually. Furthermore, it has encouraged the pursuit of life based on the righteous action called Karma.

The Threefold path to Mokhsa, which is discussed in depth later, is greatly facilitated by human consciousness. The Vedic knowledge permits the exploration of all aspects of consciousness enabling self realization or "Moksha."

It is my hope that readers will look into each aspect of Revelation in much greater detail on their own and enrich themselves with the legacy of mankind after reading this book.

INTRODUCTION

Ever since childhood I have been interested in knowing about God.

Who created the universe? Why was the universe created? What was the purpose of our life?

I was admitted to Sanatana Dharma Sanskrit English High School and it was my good fortune to have received excellent education in English, history, mathematics, science. At the same time, my spiritual education was not neglected. One of my eight classes was devoted to Dharma. By the time I finished my high school education, I had a good understanding of my obligatory duties towards my parents, brothers, sisters, family, and society. This helped me establish good relationships across my entire family tree.

My interest in history and religion stayed dormant, and during next few years my new interest in sports took center stage. Team work served me well during my entire professional career. My education in college provided me with a sound background in mathematics and physics. That led me to a Bachelor of Science degree.

When I started my engineering education at California State University, I had to make considerable use of the library facilities. We had a remarkable library that was well stocked with books in many fields.

The entire day was devoted to engineering, homework, and preparing for tests or laboratory work. The weekends were spent doing part time work to pay for my education. I devoted some evenings in the library reading about the early history of India and the then known world. Furthermore, I read about other religions such as Judaism, Christianity, Islam, Bahai World Faith, etc.

I decided to budget my time so that my engineering studies did not suffer. I had taken on the maximum allowed scholastic courses. In my second semester, I was admitted to the engineering honor's society ΦΣΤ (Phi Sigma Tau). After I graduated with my engineering degree I was awarded a **Research Assistantship**—a scholarship that paid for my graduate studies in mechanical engineering and led me to a faculty position at Kansas State University. In recognition of my promise as a researcher, I was admitted to Σ Ξ (Sigma Xi) Honors Society. While I was there I developed three goals for my life:

- become a notable teacher
- become a notable researcher
- become one of the foremost professionals in the world of aeronautics and astronautics

As I pursued my goals successfully, my interests in history and religion started to grow. I took advantage of traveling to where not only did I relax, but I visited many places in Europe and India where history had left scars and ruins of great civilizations. I started to ask myself questions such as "Why were the religions so intolerant of each other?"

The loss of life and property that was suffered by innocent population was an unforgiveable sin. I asked myself "If God created the Universe, and its creatures, why were they all let loose on earth without any guidance to regulate their behavior?" The destruction in Italy, Greece was particularly distressing to see—it left an unforgettable mark on me.

After I retired, I had more time on my hands. I played golf and made many new friends. All these people got along with each other and displayed good ethics. They had a good sense of humor and they could laugh at themselves all day, but religion was one subject to completely avoid. They all had solid, unchangeable beliefs with superficial differences.

During the year of 2011, I visited India, and as a pleasant surprise, I was gifted two special books. Mr. Vijay Sharma, an airline pilot and manager, gifted me the book entitled "Sai Baba My Pilot"—a touching book of experiences and spiritual life. All of this would have been impossible without Captain Vijay Sharma's encounters with Sai Baba.

The second book was gifted to me by my dear wife's uncle named K.L. Watts. It was called "The Religion and Philosophy of the Rig Veda" and it was written by my professor named D.N. Sharma and his son M.N. Sharma. K.L. Watts was the Director General of the Indian Police and he was responsible for India's National Security during the era when Indira Gandhi was the Prime Minister. He was married to the daughter of Professor and Principal D.N. Sharma. Professor D.N. Sharma was my English Poetry professor and he chaired the Student Council while I represented the resident students of the D.A.V College in Jullunder. Mohinder Nath Sharma was my classmate and

he later attended Punjab Engineering College to become an Engineer. He retired as a Chief Engineer.

A day earlier, I visited Bahri's (a notable book store in Khan Market, New Delhi). I purchased the book called Upanishads by Max Muller, and other books such as the Rig Veda, Vedic Mathematics and several other books.

Upon my return home to America, I read these books several times. In addition to reading them, I revisited other books in my own religious library where I have books on religions worldwide. When I returned from India, I attended local Chinmaya Mission, where Acharya Dr. P.B. Ghate gave lectures on the "Glory of Vedas."

After reading those books and attending those lectures, my desire to intensify my inquiry was further stoked.

While I enjoyed reading all those books, the question of religious intolerance, the destruction of knowledge, and human heritage bothered me.

During November of 2011, I had a golf accident which necessitated an arthroscopic procedure on my left knee. I was unable to play golf, but I had the luxury of having additional time to read more ancient Indian history. Soon thereafter, I began to struggle sleeping at night, and I had an intimate experience as if a figure was telling me that its message was distorted by human acts. The figure told me that it gave all humans freedom to act, but in return they undertook

- intolerance of my people
- destruction of human life
- destruction of revealing knowledge

The figure indicated that it affronted him.

Each time I was encouraged to correct this. My life-long love of God and learning about religions was insufficient to change people's perceptions. I decided I wanted to better understand what God had revealed and then determine what was not being correctly followed by mankind. The only place I had a hope to find an answer was in the Vedas—the oldest known books that had the record of what was revealed by God himself to the seven Sages of India thousands of years prior to prophet driven religions.

Supposedly, it provided humans all the knowledge that was needed to survive and thrive on earth. There was no requirement for setting up a religion or making it compulsory.

Everyone was encouraged to question and revalidate what was revealed. The revelation was cryptic and required considerate inquiry to come to a consensus. The Upanishads became a vehicle for this inquiry. Later on, Gurukuls carried out this task for thousands of years.

Meanwhile, I came across an article by Shri Premindra Priyadarshi called "The Struggle of Knowledge with Semitic Religions and its Ultimate Survival." This motivated me to begin writing. The first chapter of this writing is a summary drawn from this article. It was very well documented and supported, literally, by hundreds of references.

This lead to a renewed state of inquiry that originally started during my childhood. As I started to struggle with spiritualistic and materialistic knowledge that came out of dedicated inquiries of Vedic revelations, it became clear to me that key revelations had to be segregated into separate chapters. As I began writing the second chapter, I realized

that reincarnation, creation, and consciousness should be their own separate chapters.

Upanishads had a profound impact on all the religions in addition to clarifying the Vedic message. I selectively picked portions to expose the reader to the wisdom of the Upanishads. At times I felt that I was reading Upanishads in the company of Jesus Christ. A selection of his thoughts and quotes came straight from the Upanishads. Jesus used remarkable simplicity in getting his messages across.

I had documented a brief version of the key revelations that could form a basis of the code of conduct, or way of life that will support a progressive material life that is also rich in spiritual values. A society based on these principles would pursue what God wanted. He wanted a human race that would commit to developing materialistic knowledge, while at the same time constantly being aware of the spiritual realities of mankind's mission. The pursuit of materialistic knowledge was necessary to support obligatory duties here on planet earth. The pursuit of spiritualistic knowledge is necessary to fulfill self-realization. The enhanced value system would be more amenable for the people to learn to support and respect different views. The differences would then become the strength of society that recognizes diversity as an asset.

As Sanatana Dharma principles and core teachings took shape, it was impressive to note the quality of thinking following the dawn of Creation prior to 13000 BC or earlier. Timelines are troublesome in the light of fuzzy dates used in the Old Testament and other antique documents of Judaism and Christianity. Similarly, other related books erroneously state that the life of humans on earth is much more recent

than **13000 BC.** The scientists, aided by new discoveries, are busy pushing these dates back. The chapter called Cradle of Civilization and the Oldest Civilization was written to provide a peak into glory that was India—a mother of civilizations. The few pages within this chapter hardly do any justice to the subjects mentioned, but might assist in launching other inquiries.

As the book started to shape up it was clear to me that the revelation of the Vedas was so cryptic to a point that knowledgeable people around the world are still debating over it. Some scientists have come up with a new meaning that is both scientific as well as spiritual. As this process continues, organized religions will be further along on the wrong side of history. The scientists have rejected the obsolete beliefs of people as recorded in the Bible on the age of galaxies, the age of Earth, the planetary systems, and the concept of Creation.

The progress that has been made since the sixteenth century which western civilization took credit for, had nothing to do with western ideology or discoveries. It was a delayed fruition of the wisdom tree that had its origin in Ancient India.

The reader will perhaps conclude that all organized religions will sooner or later realize that time has almost made them irrelevant. It is about time that humans reassess their outlooks, revise their behavior towards each other and their governments, and ensure human freedom as a fundamental right.

The lack of spiritual content in day to day life makes a compelling case for the need to get back to the Vedas a "clarion call." All religions today could do mankind a favor by

removing the exclusivity clauses within their religions since it was never the will of God. These erroneous beliefs are the root cause of most human miseries inflicted by these religions.

The material in this book had too many sources to give sufficient credit to any one individual. I express my gratitude to all those who have revisited the subject of Vedic Wisdom over the last hundred years. I feel humbled in my attempt to offer a point of view saying that the purpose of life is to discover materialistic and spiritualistic knowledge revealed by God while leading a balanced life that is

- dedicated to excellence without desire for personal gain
- dedicated to a service to the society and world at large
- dedicated to their obligatory duties enhancing love and mutual sacrifice

History is in the process of revision to recognize recent discoveries. Some of these discoveries will probably be studied for hundreds or even thousands of years more. The dates used in this book are offered to stimulate future interest in the legacy of mankind.

A reader that takes time to understand the three God-given Gunnas (attributes) and utilizes the layers of consciousness to perform day to day duties, or Karma, will be rewarded with peace of mind. It will also lead to the reader's uplift on the ladder of reincarnation which is a promise of better life ahead. A reader who takes time to meditate and reach higher states of consciousness will be rewarded with tension-free life. A journey along this path could become further rewarding and culminate in self realization.

One might conclude that the antiquity of India precedes all known civilizations and has a continuous record of their civilization to prove it. Over two thousand and four hundred recent Indian excavations, and the release of data based on their findings will strengthen universal beliefs that India is indeed the mother of all other civilizations and religions.

KNOWLEDGE

(Revealed, Spread, Destroyed, and its
Ultimate Survival)

A great deal of my motivation to write this book came from reading an article called "The Struggle of Knowledge with the Semitic Religions and its Ultimate Survival." It was written by Shri Premindra Priyadarshi. It was well supported by hundreds of credible resources. I strongly recommend reading that article to those who are interested. A brief summary is provided as a prelude to material in subsequent chapters pertaining to revealed knowledge and its beneficial impact on humanity.

Knowledge is a gift of God to mankind. The human race does not have an exemplary record in preserving and spreading knowledge. Many authors are writing saying that modern civilization is the product of Judo-Christian tradition. Many view that as being totally false. In fact, modern philosophy and science are a delayed fruition of a tree representing Ancient India.

On the other hand, Semitic Religions did everything to suppress and destroy the development of knowledge-especially Science.

It is absurd to discuss religion while writing about the history of knowledge. Unfortunately, some religions have

suppressed knowledge over the ages to a point where the story cannot be complete without discussing it.

Up to the fifteenth century Europe was in the **Dark Age**. Historians call this period the **Dark Age** because there was no knowledge such as mathematics, science, medicine, etc. in Europe.

Long ago there was a brief period of enlightenment in a limited part of Europe referred to as **Greece** from the sixth century **BC**. This was due to the import of knowledge from India. This period is called the **First Awakening of Europe**, and the reappearance of knowledge in the sixteenth century is called **Renaissance**.

Presented here is some information on how sciences came to Greece from the East for the first time, and how it was destroyed. The scholars were killed by Romans, then by the fundamental Christians, then finally by Muslim Invaders. Ultimately, some knowledge survived and finally reached the west.

Origin of Knowledge

India has been the birthplace of science for ages. Takshashila University was a great center of learning in which students from Iran and places further west came to study. In the first millennium BC, Iran was highly "Indianite." Therefore, in a way, Iran could be considered an expansion of Indian culture and civilization. At the western fringe laid Asia Minor. (Modern day Turkey) Asia Minor was a location where interactions between Greek and Iranians occurred. Turks did not live there during this period.

In the sixth century **BC**, Iran expanded its borders to include Assyria, Babylon, the complete Asia Minor, and a major part of Greece. Egypt also fell into Iran's control soon after. While Iran was engaged in expansion on its western border, its eastern region was in peace and harmony, continuously receiving Indian knowledge.

During the 5th century BC, Zoraster lived in the eastern regions of Persia which was not far from India. His belief to wage war on the evil, his idea of constant struggle between good and bad, and constant struggle between light and darkness is believed by scholars of Theology to be of Indian origin. (Upanishads) Monotheism had reached full development in Upanishads literature in India. Thanks to the Upanishads, Zoroastrianism, Judaism, and also Akhenaton (1350BC) of Egypt were able to borrow generously. Upanishad knowledge did not stay in Egypt. It faded away after death of its only patron Akhenaton.

Mithraism was another branch of a Vedic religion that was spread widely over Iran, South Europe, and Egypt. Mithra is a Vedic God of the Sun. Mithras celebrated the birthday of Mithra on December twenty-fifth which was adopted by Christians as the birth date of Jesus Christ.

The religions of Indian origin in the Middle East introduced the principles of righteousness and monotheism to Judaism, Christianity, and to later on to Islam. Excluding those, Indian colonies existed in Alexandria, Egypt, Akkad, Babylon and other parts within the Middle East. Indian sea traders and land travelers also played their role until the rise of Islam.

It is also relevant to clarify here that the central dogma of the Indian Vedic Dharma is knowledge. It believes that

knowledge of truth is the ultimate goal in life. It also recognizes that, although there is only one absolute truth because of the limitations of human sense organs and mind, truth may be conceived differently by different individuals under different circumstances. Because of this, tolerance of differing opinions was preached. One must remember that tolerance for the difference of opinion is the first requirement for growth of knowledge in society. The Indian Sages maintained that knowledge is relative.

India gave the world its earliest version of theory of relativity and formulated a unified field theory of physics. The laws of cause and effect and karma became the basis of reincarnation. It was explained that what people get in life is as a direct result of divine cosmic laws referring to the chain of cause and effect, karma, and not fate.

The doctrine of karma holds people responsible for their acts. Truth was considered to be a subject of investigation and not belief. The universe (Samsara) is only a sum total of the complex system of causes and effects flowing in time. Vedic religion encouraged people to know and experience God rather than just believing him. Because of investigative temper, India was ahead of all other nations in the science and mathematics department.

On the other hand, the Jewish religion was based on the faith saying that only their God is real and all others are false. Hence it is not belief in one God, but a belief in correctness of one religion. Christians and Muslims adopted the same attitude. Fighting the nonbeliever became the prime duty of believer. Further, the words of God as revealed to their Prophet

are final and anything contradicting this has to be destroyed. This gave a rise to the concept of heresy.

Pythagoras: A Great Hindu Genius

History of knowledge in Europe starts with Pythagoras in the sixth century BC. He was the first European who brought Indian knowledge and mathematics to Greece in an organized manner. He was also the first European to adopt Hinduism as his way of life. There is no conversion in Hinduism. Pythagoras was born around 560 BC in Samos-an island not far from the coast of Asia Minor.

After studying in Greece, he went to Egypt which had already received Indian geometry through its contacts with Indians and Indo Iranians. There were scholars teaching geometry and astrology. During his stay in Egypt, Egypt was invaded by Iran. He was brought to Iran as a captive, where he stayed in Babylon and other various cities.

Babylon was no longer a Semitic city by that time. It had been thoroughly "Indo-Iranized" in language, religion, and knowledge at large for more than a century earlier. It happened when the Medes and Persians thoroughly overran the country of Babylon, became part of the great Persian Empire physically, and culturally became a part of Indo-Iran.

Pythagoras travelled through Punjab and to the Himalayas as well. It thoroughly changed his life style and thinking. He permanently rejected long Greek robes and he adopted trousers turning away from Ionian culture which identified himself strongly with East.

5

Having lived for over twenty years in the East, he returned to Europe and settled in Groton—a Greek speaking town of in Southern Italy. He formed an order of ascetics devoted to a sense of community with the help of religious injunctions and instructions. This was to give the members a real insight into the concordant nature of the universe. He preached that the world, like human society, was held together by the ordinary arrangement of its parts. He stressed that it is our clear duty to cultivate order in our own lives. He was now acting as the Ambassador of Hinduism to the west.

Pythagoras believed in transmigration of life through different life forms. He was a firm believer in Karmic law and preached immortality of existence. The human body is temporary; therefore one must purify the soul by abstaining from bodily pleasures. By these means, soul would ultimately win release from the birth and rebirth, realizing the true divine status.

Pythagoreans studied and they further developed the science of mathematics and philosophy which were brought to them from India by their Greek Guru. The actions started by Pythagoras resulted in a boom of scholarships in Greece. Finally, we find authorities like Socrates, Plato, Aristotle, Descartes, Heraclites, Eratosthenes, Archimedes, Euclid, etc. During this whole period, the transfer of knowledge from India to Greece was never interrupted. This may be assumed from the fact that whatever theory was given in India appeared in Greek translation soon after. The examples are Atomic Theory, Theory of Micro-Organisms, Theory of Non-Dualism, Brahman, Atman, and The Five Elements. (Excluding space for Greeks)

A growing and living civilization is always ready to find out and assimilate whatever valuable it notices in other civilizations.

Alexanderia University: Center of Indo-Greek Learning

After Alexander the Great established the Hellenistic Empire comprising of Egypt, Asia Minor, Iran, Bactria, and Northwest India (including Punjab and modern Afghanistan) the transfer of learning from India to Greece was very much increased. Alexander himself rounded up hundreds of scholars and took them to Greece to increase the wealth of knowledge in his country.

Tens of thousands of Alexander's soldiers married Indo-Iranian women and took them to Greece. Trade routes and diplomatic channels were also established which facilitated the flow of knowledge from India to Greece.

When Alexander came to India he was highly impressed by Takshashila University in Punjab. Being inspired by the University, Alexander established a great university in Alexandria, Egypt. This was the first university ever built outside of India. In Alexandria, scholars from Greece, Iran, India, and Egypt would come to study and teach. A large number of Indian texts were translated to Greek and kept within the library located in Alexandria.

When Jesus started his religion, he was very much like an Indian ascetic. Like Hindu saints, he followed renunciation, practiced Celibacy, and preached nonviolence. It is claimed that

7

Jesus spent many years in India and received spiritual training in Indian tradition. While that was taking place, this part of the world was inhabited by a significant population of Hindus. When they converted to Christianity, they introduced many things into this religion for example folding hands Indian-Style whenever praying to God, ringing typical Indian-style bells in churches, introduction of a circular Halo around the picture of Jesus, etc. Practices of celibacy, renunciation of material life by monks, and asceticism adopted by Christian saints were Hindu influences on Christianity. These practices are not found in Semitic religions.

The vast majority of people who initially accepted Christianity were Jewish. Because they were Jewish, they brought the Old Testament (The Jewish Scripture) and most of the beliefs and practices of Jews. Therefore, after the death of Jesus, Christians believed the same as Jews did. Christians now believed that their religion was the only right religion and, furthermore, that Jesus is the only true god. Christians also believed that Sorcery, Miracles, Witchcraft, Mysticism, Idol Worship, etc. are satanic acts. According to them, people accused of being involved in them should be killed. Raising any doubts or suggesting modification in religion was termed heresy which was punishable by death. Fighting non-Christians and converting or eliminating them was considered a religious duty.

The new religion was anti-science, because science did not support what this religion preached.

Destruction of Greece and Demolition of Alexanderia

In the third and second centuries BC, Rome became a big power. Having no respect for Knowledge, they destroyed much of the Greek civilization. They extended their empire to include North Africa, Asia Minor, and South Europe.

Greek tradition of learning was disrupted in Europe when scholars were killed and cities were destroyed, although it continued in Alexandria. A few Greek scholars escaped being killed in Europe and they continued their pursuit of knowledge up until the Byzantine period.

It was Justinian, the Byzantine Emperor, in five-hundred twenty nine AD who closed the nine-hundred-year-old academy of Plato in Athens and completely destroyed the remains of Greek knowledge in Europe. He claimed it was a hot bed of paganism and heresy. The scholars were killed or converted. Many of these Greek scholars were scared of losing their lives and intellectual freedom, so they fled to Persia and established a kind of academy.

In early fourth century AD, Constantine, who had become Christian and rose to power, made Christianity the state of religion.

Non-believers were persecuted, burned, and murdered by animated Christian mobs called zealots. Mathematicians, scientists, and philosophers were particularly targeted. Europe was entering the **Dark Age** with complete elimination of all the works of science, mathematics, and philosophy. The University of Alexandria, however, still survived in Egypt.

During the year three-hundred and eighty nine **AD**, Christian emperor Theodosius ordered Theophilus, the bishop of Alexandria, to destroy all pagan monuments. Hindus were called Pagan by them. The Christian mobs burned the Pagan scholars and also the library in the University Of Alexandria.

There was much mistrust among Christians, Jews, and Pagans. Very few scholars survived and continued their work. In four-hundred twelve **AD**, a fanatic named Cyril became the Patriarch of Alexandria. He began a campaign to rid the city of both Jews and Pythagorean scholars within it. In spite of it, the University Of Alexandria still survived.

In six-hundred and forty two **AD**, Caliph Omar overran Egypt. The victorious Caliph ordered books that were contrary to Koran beliefs, and books that stated Koran was superfluous must be destroyed.

The University Library was finally razed to the ground. The volume of manuscripts was so large that it burned for six months.

With the exception of those who converted, the scholars were slaughtered. Books were searched for and burned throughout all Egypt and Libya. As a result of this, the history and literature of Egypt was lost forever. The same can be said of Greek and Babylonian history.

The end of knowledge in the West was complete.

Indian Scenerio

In India, the scenario was different. Science, mathematics, logic, philosophy, and art were growing at an unlimited pace.

India's revealed knowledge's focus was on the pursuit of total knowledge. Arguments were encouraged in Religious Matters, Religious Philosophy, and Meta Physics. Inquiry and thus scientific bias was cornerstone of deciphering the revealed knowledge.

The scientific bias of the Vedic religion had led to the growth of science much earlier in India from which Pythagoras and many other people of the west had benefitted from over the ages.

The Vedas revealed all knowledge that was deemed necessary for human survival and advancement. It included spiritualistic as well as materialistic knowledge. Materialistic knowledge was deemed necessary to carry on effective karma while benefitting human advancement. The pursuit of spiritual knowledge was encouraged to enhance human progress in the reincarnation cycle and its ultimate freedom from birth and rebirth called Moksha. The Law of Conservation of Matter and Energy and the Law of Cause and Effect were two fundamental Cosmic Laws of Vedic-revealed knowledge. Those who did not accept these laws were considered agnostics. The agnostics and people who did not accept the existence of God were considered equally respected as others.

Indian society considered religion or belief a matter of personal choice, and they did not enforce it to anybody by the state, family, or society. Needless to say that Fatwa or religious decree, as in Islam, was beyond imagination in India. By the twelfth century India had become paradise on earth and established itself as the "Cradle of Civilization"

An eminent philosopher and historian named Will Durant said "India was the motherland of race, and Sanskrit was

the mother of European languages. She was the mother of our philosophies, mother through Arabs of much of our mathematics, mother through Buddha of the ideal embodied in Christianity, mother through village communities of self government and democracy. Mother India is in many ways, the mother of us all."

It started to change in the 12ᵗʰ century AD as North India fell to Muslim invaders and Mohammed Ghouri established the Delhi Sultanate. All the great Indian Universities such as Taxila, Nalanda, Odantapuri, and Vikramashila were burnt down to ashes. All the inmates were killed by Muslim Commanders propelling India into darkness. Scholars were hunted down and the Indian system of education was abolished, ultimately being replaced by Islamic Muderssas.

All education needs state funding. Once the state was under Muslim rule, all indigenous knowledge vanished. The only exception was Sanskrit grammar, a bit of mathematics logic, medicine, and philosophy, which was preserved by individual efforts of practitioners and scholars. To sustain their lives, these scholars had to serve as priests in households.

Once the light of knowledge was gone, ignorance and social evils embraced India from all sides. Even books of history were burnt down. In the eighteenth century, India had no knowledge of its pre-Muslim History.

Many books dealing with religion, philosophy, and history were taken to Sri Lanka, Burma, Tibet, and China which is where much of Indian history has been reconstructed.

A remarkable incident occurred in seven-hundred and seventy three AD, when a delegation of diplomats from the lower Indus Valley region arrived into the new Arab capital

of Baghdad. They were dressed in bright silks, turbans, and glittering gems when they arrived outside the gates of Al-Mansur's (the founder of the Abbasid dynasty) magnificent city.

Remember during this period India was still basking in glory and did not fall to any invasions until the twelfth century. This particular delegation brought with them an Astronomer named Kanaka. Being an expert on eclipse, he carried with him a small library of Indian astronomical text to present to the Caliph. These works included Surya Siddhanta and works of Brahma Gupta. (Containing material on Aryabhata)

According to the Arab historian Al Qifti, the Caliph was amazed at the knowledge of the Indian texts. He immediately ordered them to be translated to Arabic. Their essence compiled into a text book that became known as Sind hind. (Sind hind is the Arabic form of Sanskrit word Siddhanta)

Once the works of India came into the sphere of early Islamic scholars, this knowledge began to enter the Christian-populated Europe through Syria, Sicily, and the Arab-controlled Spain.

A version of great Sind hind was translated into Latin in one thousand one hundred and twenty six AD. Dozens of critical documents of various disciplines, similarly, made their way to be translated to Latin.

All Caliphs from Al Mansur onwards started showing interest in science and philosophy. These people had come from the deserts of Arabia and they were illiterate. They brought little materialistic culture to the ancient civilizations that were now under their sway.

The initial reaction of the Muslims over running these civilizations was hatred for the infidel, causing large scale destruction of knowledge wherever Islam went.

The credit should be given to early Abbasid Caliphs who transformed their people into a knowledge-loving nation, although it only lasted for only few centuries. During this period of reign of Al-Mansur and his successors (809-833 AD), Indian texts were brought to Baghdad on a large scale where they were translated into Arabic. These were studied along with Arabic translations of the Greek knowledge.

Scholars, engineers, scientists, and artists flocked to Baghdad where they were honored and well paid. This was a great era of translation. This project was made infinitely simpler when the first paper factory opened in Baghdad in 794 AD. The paper factory used processes that were learned from the Chinese. As the translations of Indian manuscripts began to stack up, Al-Mamum ordered a museum and library complex to be built. It was completed in 833 AD and became known as House of Wisdom (The Arabic translation of House of Wisdom is Bait-al-hikma). This House of Wisdom was now third in size to Taxila and Nalanda Universities.

The Zero, Decimal System, Indian numerals, astronomy, astrology, trigonometry, ayurveda, chemistry, and everything that was Indian, even up to dream analysis, had now reached Baghdad. The local Iranian scholars were now in a position to formulate further theorems. Fascinated by Indian astronomy, Caliph Al-Mamum ordered an observatory to be built in Baghdad in 829 AD and soon after others outside of Baghdad.

A lesser well known fact is that initially all scholars known as being Arabic were actually Iranian. For example

Al-Khwarizini and Al-Biruni. Some of these Arabic scholars were even Spanish.

The Indian ideas reaching Baghdad sparked off an intellectual revolution. When the Baghdadi's learned from translations, from the works of Aryabhata, that Earth is a sphere with a diameter of eight thousand three hundred and sixteen miles rotating on its axis, many of them believed it and wanted to measure it themselves. Similar inspiration led to development of experimentation of Abbasid people.

Arabs who were always engaged in expanding their frontiers into Europe did not ever invade India after the initial conquest of Sind. The genocide and forced conversion was stopped, perhaps, out of the respect for India.

India, however, had later invasions that continued up until the invasion of Babur and the formation of the Moughal Empire in India.

The greatest mathematician of the Arabic Empire known as Al-Khwarisoni led two scientific missions to India to meet scholars and collect manuscripts. Based on these, he wrote a book called Kitab-al-Jabrwa al-muqabalah. Later, many of these books made their way into Spanish Cordova where they were translated into Latin.

Knowledge Moves West

Some of the earliest translations of Arabic manuscripts to Latin were penned in Northern Spain beginning in the mid tenth century at the monastery of Santa Maria de Ripoll. In the tenth century, Gerbert of Aurillac (946-1003AD) learned

the Indian counting system from the Moors Of Spain. In 909 AD he became Pope Sylvester II. In the 990's he taught Hindu numerals to his students and monks.

Al-Khwarismi's Algoritine de numero Indorum was translated to Latin by an English man Robert Of Chester who lived in Spain in 1120 AD. The Indian astronomical works, as translated by Al-Khwarismi, were translated into Latin in Cordova Spain during the year 1126 AD. This brought Indian numbers, arithmetic, algebra, and astronomy to the Latin world. This also contained the works of Aryabhata.

Aryabhata's work contained fractions, quadratic equations, sums of power series, sine, cosine, equations of imaginary numbers, square root of—1, and so on. He wrote saying that planets and the Moon do not have their own light, they reflect the light of the Sun.

He gave radii of planetary orbits in terms of Earth and the Sun. His calculation of Earth's diameter which was 8316 miles was very accurate and still stands today. Incredibly he believed that the orbit of planets are ellipse and not just circles. He correctly explained the causes of eclipses of the Sun and the Moon. This vast literature laid in the hands of Europeans now. This was going to provide the knowledge base required for future scientific discoveries. The knowledge assisted Kepler, Copernicus, and Newton to become famous.

Even though Muslims destroyed India's immense knowledge base, they now began to utilize this, ushering a progressive period in the Middle East. All this knowledge came to fruitation hundreds of years later. It was known as the Renaissance.

Arabs were not so lucky. Baghdad was first destroyed by a civil war among later Abbasids. Then, in 1258 the invading army of Genghis Khan destroyed it down to the last brick.

Although the Islamic Empire was reconstructed, the scientific temper of the Abbasids was to never be restored to the Arabs.

Later, when Abdul Wahab started his movement, Muslims would look more and more to its religious books instead of investigating the truth in the materialistic world.

Conclusion

Knowledge has survived, in spite of all odds against it. Not only in science and philosophy, but in many other fields, the West has borrowed heavily from India. Europe got all of its Indian mathematics and philosophy through the Arab channels. When British came to India, they had firsthand knowledge of the Indian philosophy.

Goethe, Schopenhauer, and most other German philosophers have studied Indian philosophy and were influenced by it. In the English speaking world, the strongest Indian influence was felt in America where Emerson, Thoreau, and other New England writers avidly studied a bunch of Indian religious literature. Their translations and other contributions exercised immense influence on their contemporaries and successors. The list of authors who admitted to have Indian influence is too large. To name just a few, it includes luminaries such as Carlyle, Richard Jefferies, Edward Carpenter, Stephen Zweig, Romya Rolland, and Jung.

GOD REVEALED
KNOWLEDGE

(Through the Vedas)

The Vedas are the oldest known piece of literature in existence to mankind. Literature is a tool to learn the historical prospective and evolution of civilization and thought. Immediately after creation, God revealed all needed knowledge to the seven Rishi's named Attri, Bharadwaj, Bhrigu, Kashapa, Kanva, Vashishta, and Vishvamitra. The Rishi's passed this knowledge on to other Rishi's. For thousands of years, it was passed on from generation to generation by dedicated sages who committed it to memory.

It was eventually written down in the DevNagri language, which is the predecessor of Sanskrit or mother of all Indo-European languages.

There are four Vedas which are further sub-divided into Samhita, Brahmanas, Aranyakas and Upanishads. The four Vedas are:

- Rig Veda
- Yajar Veda
- Sama Veda
- Atharva Veda

The **Rig Veda** is the most significant of the four. There are 10,552 mantras, or hymns, in the Samhita portion of this Veda. The Yajar Veda Samhita has 1,975 mantras and the Sama Veda Samhite has 1,875 mantras. 1,504 of these hymns are taken from the Rig Veda. 371 new hymns are added. The Atharva Veda Samhite has 5987 mantras. The Samhite portion of the Vedas is believed to be the revealed divine knowledge.

Vedas are the voice of God. The sacred word, or Vak, was expressed by the Supreme Lord, or Ishwara, himself in the beginning of Creation.

The Vedas are credited with the almighty creator revealing all knowledge needed by mankind, ushering an era of inquiry. The narrative of hymns is in the finest form of poetry known to mankind. These, however, are Cryptic in the manner that hymns reveal information. There is no better illustration of this than the hymns that describe creation.

For mankind, a tremendous reward existed if one could decipher the true meaning, or all the different meanings that were intended. God gave mankind a free will to act as pleased. In order to ensure that creation progressed harmoniously, several Cosmic Laws had to be established. Mankind could still violate these, but a price had to be paid.

The creation could grow or shrink depending upon the action of humans. The generation of matter and anti-matter controlled the status at all times.

To comprehend the immense amount of materialistic and spiritualistic knowledge that was revealed required a significant degree of consciousness. Mankind was provided the most advanced gift of consciousness from God. This could now

cope with materialistic as well as spiritualistic advancement. This aspect of revelation will be discussed in a later chapter.

Many writers describe the Vedas as hymns in praise of nature or God. There is more to it than just praising the many manifestations of God.

Early people found the Vedas to be very enjoyable to read due to the structure of its writing. One wants to read these again and again. Some felt compelled to sing these hymns. Some adopted these for use in performance of the Yagnas. Some had enough material that it provided guidance in day to day living.

The scholars maintain that the search to find the true meanings of these hymns is the most important purpose of all.

All these multitudes of needs led to an early problem for the scholars. They wanted to ensure that everyone reads so that it sounded the same no matter who read it. It then led to the birth of the Vedanga's.

Siksha was the Vedanga devoted to pronunciation and the correct accent. Vyakarana was the Vedanga devoted to grammar making Sanskrit the first properly structured language in the world thousands of years prior to any other language. Nirukta was the Vedanga focused on the formation and meaning of words. This led to many works of prose, drama, short stories, and ultimately epics such as the Ramayana and Mahabharata.

Eighteen puranas contain short stories that cover the fundamental truths of religion and morality.

Ancient India—A Land of Sages and Scientists that Used Revelation to Improve Life of Common Man

As the society grew, the other needs including structures, sanitation, flow of traffic, water harvesting, and sewerage disposal grew. Medical sciences grew to assure the solution of various health problems leading to ayurveda. Ayurveda consists of pharmacology which utilizes herb-based medicines free of side effects, surgical tools, and well developed procedures. Over 120 surgical instruments were widely used. These were ultimately transferred to the West via the East India Company.

The Vedic structure encouraged people to sing and dance. This lead to Gandharva Veda which addressed music and Dance fundamentals.

The state administration and rules of commerce were not neglected and became the subject of discussion in Arthashastra.

From the material and table presented, it is clear that the Vedic knowledge covered a broad range of subjects. This knowledge was widely used giving rise to music, dance, arts, science, mathematics, civil engineering, and astrology. Instead of bundling all revealed knowledge together, I decided to separate some key elements into separate chapters such as creation, consciousness, and reincarnation. These three revelations are the foundations of early Indian civilization. For that reason creation, consciousness, and reincarnation were given separate coverage.

The order of their discussion has no significance. Some repetition of concepts has been found necessary for the sake of clarity.

Birth of Arts, Science, and Mathematics from Rituals

Unlike many other old civilizations, Indian civilization encouraged inquiry and this led to rapid progress in mathematics and sciences. Astronomy made great strides due to the demands of rituals practiced as out lined in Yajurveda. This led to the earliest known, most precise, celestial calculations and astronomical time spans. Indians were the first to discover that Earth rotated around Sun. The length of a solar year was calculated to be 365.358 days and the computation of Pi was 3.1415926.

Astronomical time spans were another major step leading to very large numbers, and were totally unknown to most other civilizations. Carl Sagan states that "A millennium before Europeans were willing to divest themselves of Biblical idea that the world was a few thousand years old, the Mayans were thinking of millions, and the Hindus billions."

Mathematics and computer science foundations were laid in early Indian thinking. An Indian mathematician named Pingala (100 BC) developed a system of binary enumeration converted to decimal numerals. He documented this in his book titled Chandala Shastra. The system described by Leibnitz, who was born in the 17th century and had studied much of Indian literature published as Arithmetica, was quite similar. A translated Indian

source was documented into Arabic during reign of the third Caliph in Baghdad and later into Latin in Cordova, Spain.

The credit for the earliest and the only known modern language goes to Panini from 400BC. He gave formal production rules and definitions to describe Sanskrit grammar. Starting with 1700 fundamental elements like nouns, verbs, vowels, and consonants, he put them into classes. The construction of sentences, compound nouns and more were explained as ordered rules operating on underlying fundamental structures. These are production rules of modern day computer science. On the basis of just under 4000 Sutras, or rules expressed as aphorisms, he built virtually the whole structure of the Sanskrit language. He used a notation precisely as powerful as Backus normal form-an algebraic notation used in computer science to represent numerical patterns and other patterns by letters.

The very first notion of zero, as a number, was also discovered in ancient Indian mathematical literature. This concept combined with the place-value system of enumeration became the basis for a classical renaissance era in Indian Mathematics. Brahmagupta, an Indian mathematician, attempted to provide rules for addition and subtraction problems involving zero. He also said that any number multiplied by zero is zero.

Further mathematicians in India invented the base ten system in ancient times. Very large numbers are mentioned in Yajurveda Samhita such as 10^{12}. In later years, numbers as large as 10^{53} have been used in Indian texts. The Greek and Chinese used numbers as large as 10,000.

The invention of various mathematical series leading to the discovery of calculus was documented by the Indian

mathematician named Madhva. He discovered a series for sin(x), cosine(x), and arctan(x). Recently, a book entitled Vedic Mathematics showed the amazing progression of algebra in the Vedas. He translated eighteen Sutras of Atharveda to demonstrate the advances in Algebra.

The Vedas clearly conveyed that mankind has mind and materialistic needs. Without proper training or education, the materialistic needs of mankind cannot be met. Without the correct spiritualistic focus the correct balance cannot be developed in our minds. In order to achieve these goals a unique educational concept was developed.

Gurukul Education System Key to Balanced Material & Spiritual Education

Education was considered a very important aspect to achieve the four aims of human life:

- Dharma (Virtue/Righteous Action)
- Artha (Wealth)
- Kama (Pleasure)
- Moksha (liberation from the cycle of birth & rebirth)

It is vital to propel Dharma. Without it we cannot regulate our society or our families properly and in harmony and peace.

Education is a way an individual can gain correct knowledge, control their desires, and learn to perform their obligatory duties with a sense of detachment and devotion

to God. In this manner, one can overcome the imparities of egoism, attachment, and delusion then go on to achieve Moksha.

Without education, no one can rise above the physical self. Hence the belief that a person who is initiated into education is twice born, the first time being physically and second time is spiritually.

Knowledge is a double edged sword. In the hands of an immoral person it can become a destructive force. With knowledge comes power. If it falls into the hands of an ill-equipped person, who is bereft of morality and the sense of responsibility, he may misuse power and bring misery to himself and others.

The difference between a good and bad person is that one uses their knowledge for the welfare of the world, and the latter for his own selfish and egoistic aims.

So far, primary focus has been on materialistic knowledge that was developed by the Indian society. It was inspired by the Vedas and necessitated by religious and social needs. We have not focused on the spiritual content of the Vedas and the associated literature yet.

Most of the literature has gone overboard in just spiritual focus. In getting across a balanced picture, it was felt that some description of the educational system of that period was necessary.

As a part of their education, in ancient India, the students were advised to follow the righteous path and contribute to the welfare of society.

Vedic scriptures recognize two types of knowledge which are the lower knowledge and the higher knowledge. The

knowledge of rites and rituals and the scholarly study of scriptures is considered to be lower knowledge. In spite of this Vedic guidance, most people over the ages have been enamored about this education. The higher knowledge is knowledge of Atma, or the soul, and Brahman, or the Super Soul, gained through personal experience or self realization. The pursuit of higher knowledge has been stressed, for it alone can liberate humans from the birth and rebirth cycle. Mankind's mind has been gifted with many layers of consciousness to achieve both materialistic and spiritualistic goals. These subjects will be discussed in later chapters.

Material Knowledge Necessary to Perform Obligatory Duties and Karma

While materialistic knowledge is not stressed in lofty terms, it is recognized that no one can support existence with higher knowledge alone. We need materialistic knowledge to navigate through the material world successfully before we can realize the value of higher knowledge, and then we need to prepare ourselves to achieve it.

We need to experience life in all its hues and colors and perform our obligatory duties as expected of us to be qualified for progress in the spiritualistic plane. Salvation cannot be gained by escaping from the challenges of life, but through a process of inner transformation that can only happen when we face them and learn to deal with them suitably. We have to learn the lessons that life has to teach us.

A system of education that evolved centered on the teacher, or guru, and a bunch of dedicated students. In earlier days these teachers had acquired considerable materialistic and spiritualistic knowledge through their own experience, practice, and deep insight. They were eager to impart this to their students. This system enabled the acquiring of both materialistic and spiritualistic knowledge.

While the parents were responsible for their children's physical well being, their spiritualistic well being was left to the teachers. The students mastered the scriptures completely and recited all the verses from memory. This early system relied heavily on memory. It is because of this approach that revealed knowledge could be carried out for thousands of years later. This system of education was called the Gurukul System.

This system was a bold experiment in education which, even today, is one of the finest contributions of India to the field of education. There are two aspects of Gurukul education that need to be emphasized. The first is the type of education imparted at the Gurukul. The second is the method of education, which made Gurukul unique.

They provided truly liberal education. The purpose of the teacher was to awaken intelligence among his students. The students that came out of Gurukul's were inquirers whose process of inquiry never dimmed. It was because of this that the student who passed out of Gurukul never displayed dogmatism or arrogance. When the student left, it was stressed that their education had not ended, but rather it is just starting. They were exposed to their obligations as a part of their family and as a member of society.

The role of the five senses was stressed, particularly hearing. The role of voice, correct spelling, and pronunciation was also stressed. The pursuit of materialistic and spiritualistic knowledge concurrently produced great citizens. The Gurukul system did not put arts and sciences in compartments, leaving students the freedom to pursue their interests.

These Gurukul's were usually located outside the urban areas and far from the buzz of towns and cities. Admission into these was not difficult; however, it was important to gain the trust and confidence of the teacher. Without this trust, the student would not realize their full potential. The students lived in teachers' households. They performed all household chores that were assigned to them. The students had to display their intelligence, sincerity, and discipline along with their desire to learn before the teacher would select them for advanced subjects.

Life in the Gurukul system was hard. Students were subjected to rigorous discipline. They had to live in an austere environment, practice celibacy, practice cultivate discipline, and practice virtue under the supervision of their master to gain the teacher's attention and confidence.

As time progressed and as population grew larger, universities were established at Taxila, Benares, and Nalanda. These universities attracted students from the entire known world.

Many notable Greek scholars acquired their education in ancient Indian universities and carried the knowledge that they acquired with them to Greece.

Vedas Deal with Four Kinds of Knowledge

- Jyan (Knowledge in general)
- Karm (Action in general)
- Upasana (Communication with god)
- Vijyan (Philosophy or Meta physics)

Jyan

So far we have been mainly talking about materialistic knowledge or Jyan. This is the first subject of the Vedas. The origin of astronomy, mathematics, medical Science (ayurveda), Physics, Botany, Zoology, and many other subjects are found in the Vedas.

Karm

Karm means all types of actions (activities) that are physical or mental and with or without a desire for reward. The Vedas teach all these and explain in short or in detail all aspects and needs of human conduct which may be helpful in making the human life cultured and uplifting. Celibacy, education, teacher-student relations, married life, social order, politics, administration, discipline, governance, charity, goodwill, and cooperation have all been explained in the Vedas. Besides, the emphasis has been laid on unity between physical and mental actions as well as knowledge and actions. The Vedas instruct mankind to attain all four objects of life which are

righteousness (dharam), wealth (arth), kaam (fulfillment of desires), and moksha (Salvation).

Upasana

Upasana means meditation and communion with the almighty God. The Vedas have laid considerable emphasis on the worship of God.

Vijyan

Vijyan or meta physics means realization or acquiring correct knowledge of all things ranging from the almighty God to the ordinary blade of grass and tiny insects. Vedic philosophy deals with the nature of existence, truth, and knowledge.

The Vedas contain all the knowledge for righteous living. The knowledge is given in the form of formulas. The Rishi's expanded their knowledge on the basis of these formulas.

The five senses aid in acquiring knowledge of external things. This is true of materialistic things. The development of arts and sciences has greatly benefited from these God-given aids, or senses, or their refinement through scientific endeavors. Mankind can only see a limited distance but aided by a telescope this can enhance our capability. The same thing is true of radar which can not only see far but you can be selective choosing different frequencies. The same principal

applies to other enhanced senses. Voice can be propagated further with loudspeakers, radio transmission in different frequency bands, etc.

When it comes to learning about internal objects or things such as Atman, or soul, the five senses are of little help. The revealed knowledge is the only thing that helps. The many layers of consciousness can only be accessed through revealed techniques such as yoga.

The subject matter of the Vedas is vast. A wide range of knowledge relating to many subjects is provided:

- action and devotion
- **YOG** (Union with God by means of thought and Meditation)
- righteousness
- wealth
- desires and salvation
- parigrah (what to accumulate) and tyag (what to give up)
- preya (Actions which are appealing to follow but cause suffering in the end)
- shreya (Path of righteousness which is difficult to follow but leads to eternal happiness)
- bhautik, daivik, and adhyatmik (material relating to nature, and spiritual respectively)
- human life and means of its progress and development.
- there is nothing related to human life, materialistically or spiritually, which has not been referred to in the Vedas.

The Vedas contain divine knowledge given to us by God for the benefit of all souls. This knowledge has been in existence since the beginning of human creation. The teachings are universal and are for all mankind. In fact these books contain morals, principles, and teachings for the welfare of the entire humanity.

Vedic literature stresses righteous living which requires certain qualities:

- Dhriti—patience, firmness and stability.
- Kshama—tolerance and forgiveness.
- Dam-self-control and contentment.
- Astey—not to steal or conceal unselfishness.
- Shauch-cleanliness, purity, and honesty.
- Indriya Nigrah—control of senses, control of desires, celibacy.
- Dhee-experience gained from the actions based on true knowledge.
- Vidya-knowledge (materialistic and spiritualistic)
- Satyam-Truth.
- Akrodh—Not to get angry, avoiding tension.

The presentation so far has provided both Spiritualistic and materialistic content of the Vedic knowledge.

REINCARNATION

The meaning and definitions of Reincarnation and Incarnation:

- Reincarnation is the repeated cycle of incarnation or rebirth and a new physical body.
- Incarnation is the present life in your present body.

Reason for Reincarnation

Reincarnation is the cycle of death and rebirth after a given time from spiritual spheres into a new physical body. Such a rebirth is called reincarnation. The soul, or the true self, remains the same while the "vehicle" of the soul, to make the needed learning experience, changes.

Death means the loss of one vehicle that the soul was using during its many reincarnations in a physical body. The soul, or *atman*, is used here interchangeably.

Reincarnation in a physical body is needed to go through certain spiritual lessons that a soul may need on a particular planet. Reincarnation is controlled by the Law of Karma.

The family, time, place, social society, and culture in which reincarnation takes place are decided by the individual karma of the soul. It is a choice of the soul because it might be

necessary to become a free soul. Sometimes reincarnation is dependent on the desires, fears, and attachment only making rebirth or reincarnation that takes place in accordance with these factors a result of spiritual ignorance. Most of the time reincarnation is caused by ignorance of spiritual truth and karma. All lessons to be learned can be learned in an easier, more loving atmosphere in spiritual universes. There are only a few lessons such as conducting war, abuse of might, and violence of any kind, including mental violence by thoughts that may require a physical reincarnation because here on the physical plane, the damage is relative to the physical plane and least compared to a possible damage in astral or causal spheres.

When death occurs, the soul, including all other bodies of lights (such as astral body or causal body) leaves the physical body. It withdraws all connection to it. In fact, the consciousness normally is clearer and the perception of his surrounding is more accurate with the use of all metaphysical senses that were in its previous physical body.

Death is the result of all karma or attachment being expired. This desirable condition frees the soul to continue spiritual growth to higher dimensions of the Divine Creation. It even allows the soul to return to God. If the soul reaches the latter state it is called Self Realization, or God-Union.

Saints are sometimes capable of achieving the state of God-realization and the God-Union while still having a physical body. This is usually done during deep, highly advanced, meditation. This level of meditation is called Nirvikalpa Samadhi. Once the God-Union is reached, there is no more

need for new reincarnation. Saints sometimes reincarnate voluntarily to help mankind on a particular planet find their way home to God. They disperse and dissolve the spiritual ignorance of a culture if it is needed for the spiritual benefit of mankind. Such a soul is called an avatar.

The identification with one's physical body that leads one to fear death is caused by spiritual ignorance. The consciousness uses physical senses while being in a physical body, uses sense organs of the astral body while being in an astral world, and uses their casual senses while being in a causal world. It is like a good driver who uses four wheel drive while driving off road, uses a race car on highways, and uses a truck for farming. A soul can change the vehicle it uses by adapting to the needs of spiritual development of the consciousness of mankind.

Continuity of Consciousness During the Entire Cycle of Reincarnation

Human consciousness is potentially the same, but independent of its dimension of manifestation. Since the vibration in spiritual spheres is much higher, one's senses and mind works the senses and mind work much faster and smoother than they would in a physical body. Life beyond the physical plane is much easier and more enjoyable. Love becomes more important in the higher dimensions and vibrations of the spheres.

The State of Awareness and Consciousness During Different Phases of Reincarnation

An easy-to-understand example may be ice, water, and water vapor. It is always the same chemically, but its state is different. Ice may be compared to the physical body of a human. Liquid water may be compared to that of the astral body. Water vapor, the gaseous form of the original water, may be compared to the casual of mankind. While vapor is practically invisible to humans, it is still the same chemically, having the same potential qualities as before when in the state of ice. Just like the human soul. A human soul, even without any form and shape, has the same consciousness and awareness as before *plus* all the experiences from previous incarnations that shall become part of the conscious mind. In addition, the clarity of communications with the divine god gives the soul, freed of a body, the wisdom and knowledge of God-consciousness in the advanced state of spiritualistic development of a soul.

The End of an Incarnation or Reincarnation Cycle

At one's fully advanced level of spiritual development, they may fully dematerialize their physical body by increasing his vibration of his physical body until it reaches the next level up of manifestation in God's divine creation. An incarnation may be ended by dematerializing one's physical body, by dropping one's physical body at will during Maha Samadhi, or by losing

one's physical body during death. (This happens in majority of mankind at this time on this planet)

The Goal is to End the Cycle of Reincarnation

It is the spiritual goal of each soul to leave the cycle of reincarnation and become free souls beyond the physical, astral, and casual universes of Divine Creation.

The physical, astral, and casual universes are "spiritual school houses" for spiritual development, and making some very basic experiences necessary to become God-realized and free souls for the remainder of eternity.

The transition between physical, astral, and casual universes is done by Yogis who have learned, through meditation, that the reference point of consciousness can be moved and ultimately lead to God reunion.

The doctrine of reincarnation is also known as rebirth (transmigration of the soul) or metempsychosis/metensomatosis (passage from one body to another). The concept of palingenesis, or to begin again, concerns the rebirth of the soul or self in a series of physical or preternatural embodiments that are customarily human or animal in nature. In some instances, divine, angelic, demonic, vegetative, or astrological states are also possible. The belief in rebirth, in one form or another, existed and is still found in tribal or non-literate cultures all over the world. This goes to show that this belief arose contemporaneously with the origins of human culture.

It is in India and Greece that the doctrine of rebirth has been most elaborately developed. This belief is shared by all the other major religions of India such as Hinduism, Buddhism, Jainism, Sikhism, and Sufism. In ancient Greece, the belief of rebirth formed part of the philosophical teachings of Pythagorean, Empedocles, Plato, and Plotinus. In modern times, religious teachers and places such as Ramakrishna, Aurobindo, schools of thought like Theosophy, various new esoteric movements, or thinkers like C. G. Jung and Fritz Perls hold on to their belief in reincarnation.

All diverse religious groups and philosophical schools of Hinduism believe in reincarnation. It is deliverance from the chain of reincarnation known as karma, samsara, and moksha that is the unique and final goal of every Hindu religious belief.

Karma and the Cause of Reincarnation

According to Indian religious and philosophical concepts, man is composed of two fundamental principals opposed to each other per nature. One is spiritual, which is the soul, and the other material, which is the body-satire. The Atman is eternal, immutable, not born, not created, and indestructible. The body is temporal, created, mutable, and destructible. The union between the soul and body is not essential, but it is accidental. The soul has to undergo a type of imprisonment, or a penalty due to avidya and karma, to which it is associated from all eternity. This process where the soul is imprisoned in the physical body has no beginning.

Avidya signifies the ignorance of the true nature of Atman, or of the distorted vision in which the Atman identifies itself, or confounds itself, with the psycho-physical organism. Due to avidya, the soul, which is eternal and non-temporal, is caught up in time and gets joined to the physical body. Birth is the union of the eternal and spiritual soul with the materialistic and temporal body.

Karma and Samsara

The nature of birth which is the condition of the body in which the soul gets united, depends on karma which signifies every sort of action whether the action is good, bad, meritorious, non-meritorious, religious, or worldly. Karma signifies the moral debit of the actions which one has done. Every action inevitably produces its own fruit, or phalli, and the subject, or actor that has to necessarily experience all the consequences of his own actions. One's behavior leads, irrevocably, to an appropriate reward or punishment commensurate with that behavior. It is the inevitable law of retribution or the law of karma. It is the law of cause and effect applied to life of every individual. According to cause and effect, everyone gathers the fruit that one has already sowed or undergoes the effect of his own actions.

The effects of all the actions which a person does cannot be experienced during one single existence. That is because while the subject, or actor, experiences the fruit of some act, they do other actions in the mean time, therefore gaining new fruit that has to be experienced. From this, it is deducted that

the soul has to be reborn repeatedly. It is believed that the soul, from all eternity, is undergoing birth and rebirth due to the inviolable law of karma. Thus is born the doctrine of the transfiguration of the soul. It is a corollary of the doctrine of karma.

The entire process of reincarnation of the soul according to the law of karma is called Karma-Samsara. Samsara means to wander or pass through a series of states or conditions. Samsara is the beginning-less cycle of birth, death, and rebirth, which is a process impelled by karma. Therefore, life is not determined or limited to one birth and one death, but is instead a samsara, a current, a course, a migration in circle, which is always determined by the law of karma. In short, human life is a Karma-Samsara-a transmigration of the soul according to the inevitable law of retribution.

The Subtle Body

In order to explain how the effects of the past actions of man are preserved in the soul after the death of the body, and how these effects produce their fruit in a future rebirth, the Indian theologians make a distinction between two types of body. One is a gross body (sthula-sarira) and the other is a subtle body (sukshma-sarira or linga-sarira). The gross body is that which is visible and tangible, consisting of the eternal senses of organs etc. The subtle body, however, is neither visible nor tangible, and is composed of subtle elements, like buddhi (intelligence), manas (mind), ahamkara (ego) etc. The subtle body encircles the soul and serves as a connection

between the soul and the gross body. Every action of man leaves its imprint, or samskara, on the subtle body and remains as a seed which has to mature and produce in due time its proper fruit.

While the gross body disintegrates at death, the spirit continues to be in contact with the subtle body which it carries forward. The subtle body together with all the tendencies, merits, or effects of karma is said to migrate with the soul at death.

Internal Reincarnation and the Change of Bodies in Present Life

Consciousness and physical form are directly related. The body and consciousness of a little baby differs from that of a young or old person. It can be said that the soul travels during the development of the body (during the aging process-from birth to death), through conceptually different bodies with different consciousness. We may not be aware how we are constantly changing our body during the progression of our life. These changes are subtle, gradual, and hard to perceive. Did we notice as children how our body grows?

We notice it only when we were reminded of it by someone who saw us after a long time.

This fact is confirmed by biologists. American anthropologist John. E Pfeiffer writes in his book "Human Brain" that our body today does not contain even one molecule from seven years ago.

41

Despite this constant change of body progression, or series of different bodies, our soul still remains the same-unchanged.

Let us say that today we are thirty years old, but we are still the same person who was five or twenty years old. We are just in a different gross body. Our current body has changed during the time. For example, we gained more abilities, strength, and knowledge, but we are the same person for the sake of external identification. We still respond to the same name and everyone considers us as same person.

This transmigration of the soul through many bodies during one lifetime is called gradual or internal reincarnation.

External Reincarnation and the Change of the Body at the Time of Death

What will happen at the time of death of the present physical body? Where will we go when we die? Do we have an influence over our next situation? Can we choose our future life?

Answers are found within the Bhagavad Gita. "As the embodied soul continuously passes, in this body, from boyhood to youth and then on to old age, the soul similarly passes into another body at death." The Bhagavad Gita further explains that the state of consciousness during critical moment of death is crucial for the choice of a new body. The virtual body encases both the soul and consciousness, and it departs from the gross body with entire data bank of this and previous lives. No data loss occurs in transition. During the next life,

in new gross body, the gross body will inherit the old soul and consciousness. In the following chapter, on consciousness, we talk about the three compartments. The first one is called the identification chamber where we restart our new identification and reestablish our reference point. We deal with the new world when we begin our new incarnation. It retains all the other assets of consciousness from the past life.

The state of being that one remembers when they quit their present body is the state that they will attain in their next life. (This relates to that portion of consciousness that is retained and transferred to new gross body)

At the moment of death, the soul and consciousness departs the gross body in a subtle body in search of a new life. The subtle body also carries our desires and thoughts that were recorded therein. All this data is now evaluated, and is part of the decision process of getting an upgrade, downgrade, or status quo. Once all this is evaluated, then a decision for the soul's next journey is determined. This transmigration of the soul from one gross body to another is called external reincarnation.

This transition is undertaken by the creator or a designee for all the lives in the creation. If God can create this entire universe, in all its diversity, and undertake creating each form of life that has all the needed faculties with millions of parts that have to function properly during the entire assigned life, the transfer from one body to another is just elementary.

In the book Man's Eternal Quest by Paramahansa Yogananda, Paramahansa Yogananda states that *if one believes in the existence of a just God, then belief in reincarnation can follow very readily, as two concepts*

43

are really dependent on one another. But what about the skeptics and atheists?

Materialistic scientists claim that they have not found any actual proof of the existence of God and hence cannot offer any proof of the existence of his just law, giving equal opportunity to all life to improve through reincarnation. To such scientists the suffering of innocent babies and other inequities of life seem inexplicable and point to the absence of a just creator.

On the other hand most of those who believe in a just God base their convictions on belief only and have no scientific proof to offer to unbelievers. They do not dare, for the most part, to scrutinize, or deeply question their faith, for fear of losing it or creating social in-harmony. They are not aware, in other words, of the existence of a scientific spiritual law that can prove their belief to be truth.

But why should not spiritual law be investigated by the same methods of experimentation used by materialistic scientists to discover physical truths? Indian Sages asked this question thousands of years earlier and set about the task of answering it. Their experiments resulted in scientific methods that can be followed by anyone to discover the reality of spiritual law and hence of reincarnation and ever other cosmic truth.

Just as germs are not visible to naked eye, but are clearly visible under a microscope, it confirms the existence of germs and that is necessary to use correct tools to reach correct conclusion. It is necessary that correct spiritual

inquiry be preceded by proper scientific approach to discovery of spiritual laws.

Yoga is the science of religion that has provided insights to human consciousness far beyond anything modern science has been able to discover. Yoga has been able to confirm some of the ancient knowledge, but not been able to refute anything.

The chapter dedicated to consciousness in this book is one of the key Vedic revelations. Upanishads have laid bare the mysteries of life and death.

The Sages observed that through concentration on the self through a constant, conscious, aloof, unidentified introspection, or watching of the various changing states of life of wakefulness, dreaming, or dreamless sleep that one could perceive the changeless and eternal nature of the self.

Ordinarily, one is conscious of his walking state, and sometimes he is conscious of his dreaming state too. It is not uncommon during a dream for a person to be aware that he is dreaming. Through yoga practices one can maintain conscious awareness during every state of being for example wakefulness, dreaming, dreamless sleep, deep sleep, the ever awake super-consciousness (the unrestricted region of mind), and beyond dreamless sub-consciousness.

During sleep, there is involuntary relaxation of energy from the motor and sensory nerves. Through practice, one can produce this relaxation during the walking state at will. In the big sleep of death there is total relaxation. The retirement of energy from the heart, cerebrospinal axis, and every other involuntary function may be accomplished voluntarily or consciously by practice.

45

The Sages of Ancient India analyzed death as the withdrawal of electricity from the bulbs of human flesh with its wires of sensory and motor nerves that lead to different channels of outward expression. Just as electricity does not die when it is withdrawn from a broken bulb, life energy is not annihilated when it retires from involuntary nerves. Energy cannot die. It withdraws upon the occasion of death into cosmic energy, and it is retained in the conscious body that moves on to the next assignment of life. This became abundantly clear when it was demonstrated that one can separate the energy and consciousness from the body consciously. The Yogis have, even in modern times, demonstrated that they can accomplish this separation at will. French doctor's files contain instances of this demonstration.

These discoveries are true breakthroughs. Those who want to prove for themselves the scientific truth of doctrine of reincarnation should first prove the principle of continuity of consciousness after death by learning the art of consciously separating the soul from the body.

The science of yoga can open the doors to spiritual enlightenment. Through yoga one can learn to be conscious during sleep, to dream at will, to disconnect the five senses consciously rather than passively during sleep, and to control the action of the heart which is like the experience of conscious death or suspended animation of the body that occurs during the higher states of consciousness.

By adopting these antique methods of yogic practice, Indian Sages gave the world a knowledge that is demonstrable. Thus, one can discover the scientific truth of reincarnation and all other eternal verities.

Reincarnation is God's way to achieve the progression of the soul through many lives here on earth. In a way, it is just like going through grades in school before graduating to immortal perfection of oneness with God.

The souls are living in an imperfect state that is unaware of their divine identity with spirit. They do not, upon the death of the physical body, automatically enter the state of God realization.

We are made in the image God. It is by the identification with the physical body that we have put on its imperfections and limitations. Until the imperfect human consciousness of mortality is removed, we cannot become Gods again.

We have been given the power to reason out where we go and whence we have come, but we do not take enough time to analyze ourselves and our lives. Our commonsense tells us that whatever our character is today is what it will continue to be tomorrow and after death as well. (It may be a little better or little worse)

The purpose of the cosmic law of reincarnation is to enable us to continually improve our imperfections, leading a virtuous life through good karma. Through righteous action and God consciousness one can wholesomely contribute to family and society at large. Our mission is to lead an exemplary materialistic life, acquiring necessary materialistic knowledge, and concurrently acquiring and expanding spiritual progression and God consciousness.

Reincarnation was discussed and debated for centuries and became accepted in India and Greece. With a passage of time, it became part of all religions including Christianity and Islam. Most of the earlier saints in Christianity wrote considerable

material in support of it. It became a core belief. After five hundred years of early Christianity, it was removed from Bible. Many of the saints who supported it were excommunicated. This was done without any discussion or any good religious reasoning. In 543AD, Caesar Justinian issued a proclamation requiring the removal of all mentions of reincarnation throughout the bible, other religious literature, or anyone who favored it in past including many saints. The pope opposed it. Seven years later he declared it invalid. The damage was done. Islam still accepts it. The Sufi's claim that it is misinterpreted in Islam. The Quran clearly affirms benevolent justice of God after death, furthermore the continuity of life thereafter.

CONSCIOUSNESS

There are several key features of revealed knowledge. Creation is on the top of that list. It reveals how the creation of universe came into being. It is not only the substance, but it's the style of Vedic revelation that created compelling sense of inquiry among the Indian Sages, scholars, and students alike. The Supreme Being created the universe through his power acting on eternally preexisting matter that constituted the material for bringing creation into existence. (R10.129)

Any potter can make different shapes of pottery as long as the material is available and the potter has the requisite skill required to make different shapes and sizes of pottery. The creation does not have just different shape objects, but it also has life. The original life was created in water and the species were primarily egg-based. The internal features provided to each of these species show progressive improvement. As species split into birds on one side (still egg based), to four legged beings such as horses, cows, monkeys, etc. a noticeable improvement in functions occurred. These later species have very sophisticated hardware and sensors along with the necessary wiring and software to receive and send signals. The kidneys, bladders, intestines, and an efficient digestive system function flawlessly to digest food.

The most sophisticated part of the human system is the conscious part of mind. Human endeavors in chemistry have

produced chemicals of various kinds combining matter with known atomic structures. Through chemical reaction new substances have been created along with byproducts of the chemical action. None of the known efforts have succeeded in creating a conscious mind within an object.

Consciousness is one of the key revelations of God through the Vedas.

Not only is the consciousness present, but it has multitudes of functions with preexisting vision. Western science has made tremendous strides, but so far it has nothing to offer that supplements the knowledge revealed through the Vedas. The Indian Sages contemplated for thousands of years and acquired a good understanding of human consciousness. The capabilities and intended use has been determined by using revealed knowledge such as the Veda Samhita (R1.34.8, 5.45.7), and Upanishads such as Taittireeya, Aranyaka, Prasna, Mandukya, etc.

The revealed knowledge expounds the various levels of consciousness. These are the state of consciousness, the nature of consciousness, the nature of truth, and the methods to attain those levels. The science of consciousness deals with consciousness at all levels including human, super human, and sub human such as these:

- Planes of consciousness (Lokas)
- Sheaths of consciousness (Kosas)
- States of consciousness (Avasthas)
- Faculties of mind
- Faculties of soul consciousness

- Levels of concentration
- Conscious qualities

Conscious Qualities

All humans have been given consciousness qualities which are the foundation for the core human value system. These qualities, or human attributes, are called Sattva, Rajas, and Tamas, also known as Sattvic, Rajasic and Tamasic Gunnas. These qualities are part of the revealed knowledge that enable us human beings to act in the right or wrong way in various situations. God has given humans the freedom to exercise their actions using these three Gunnas. The sacred Bhagwat Gita provides a good explanation of these Gunnas and how to exercise them to perform good deeds or karma.

Tamas is darkness and inertia. Rajas are inspiration, force of action, and creation. Sattva is knowledge, nobility, and sustenance. The fourth attribute beyond these three qualities is called Trigunaateeta—the absolute.

Levels of Concentration

There are five levels of concentration known as

- Dispersed
- Restless
- Concentration

- Stopping of mental activity
- Experience of absolute

An untrained mind is dispersed with no specific object of thinking. It becomes restless when it is being trained to think on a specific object. The mind will slowly begin to concentrate on an object and achieve a state of concentration.

Once a person has achieved pureness of the mind, and they choose to concentrate on the formless, they will be able to stop mental activity and open up to soul consciousness. Beyond this state one can experience the absolute or Brahman.

Faculties of Soul Consciousness

There are four main faculties of soul consciousness and truth consciousness known as Atman or Chaitanya. They are *intuition, inspiration, discrimination,* and *revelation.* Inspiration is the source, intuition is the means of discrimination and superior judgment, and revelation is the destination in the seeking of the truth.

Sheaths of Consciousness

In parallel atman, it is said that one lives in five sheaths of consciousness. The five sheaths of consciousness are *physical man, vital man, mental man, idea man, and eternal man.*

Faculties of Mind

There are four faculties of mind known as *mind proper* (Manas), *intellect* (Buddhi), *ego* (Ahankara), *and memory* (chitta). Manas is the basis of all mental cognition. All emotions, thoughts, and impressions originate and manifest there. Buddhi is intellect. Functions of Buddhi include discrimination, discerning, and judgment. Ahankara is the sense of oneself ("I") or an element of ego. This part of ego is the source of all data pertaining to mind, life, and matter. Chitta is the impression of past experiences or memory.

Planes of Consciousness

The various planes of consciousness are called *Lokas* or *Worlds.* There are fourteen worlds—seven *adho lokas* with lower levels of consciousness and seven *urdhva lokas* with higher levels of consciousness. The seven urdhva lokas can be grouped into three as human, interconnect, and Superhuman. Earth's physical consciousness is at the bottom of the urdhva lokas. The world below is subconscious. Bhur, Bhuvah, and Svah are the matter, life, and mind triplet. Bhur is the earth or physical consciousness, Bhuvah is vital consciousness, and Svah is the world of mind.

States and Layers of Consciousness

The Sages and scholars alike have explored at all levels, particularly at the superhuman and sub-human levels. The yoga tradition was a direct result of this dedicated drive to unfold the spiritual nature of humans. The higher states of consciousness are mirror image of super consciousness or God the creator. As we rise higher in consciousness, we perceive the higher truth.

For humans to lead their normal day to day materialistic life, it is necessary and useful to understand the states and layers of consciousness.

There are four commonly known states and layers of consciousness. Those who practice yoga often claim that there are seven layers of consciousness. They consider the fourth state called super consciousness to be made up of four separate increments. In each step, capabilities are enhanced and ultimately one achieves self realization.

The four stages are the waking state, the sleeping state, the deep sleep state (undisturbed sleep), and the super conscious state.

Waking State

This state is equivalent to the conscious. In this state we accept the universe as we find it in perception. Volition and memory are preserved. We make use of our God given five senses in this state. (Touch, hearing, speech, taste, and sight)

Sleeping State

In this state a person is asleep. The conscious mind is inactive and our five senses are no longer in use. In this state the mind is in a subconscious state. While our censor is asleep, the subconscious can spring into action and start dreaming. In this state, the mind sees its own immensity. In a dream, the mind sees all its glories for it has vast sweep before it and can move unchecked by the interruptions of the censor. The mind can have free play to its imaginations so that it can experience the seen, the unseen, the heard, the unheard, the felt, and the unfelt.

Deep Sleep State

In this state, a person is fast asleep and does not experience any disturbances. Not even a dream. In this state a person does not hear, see, or feel. The person is completely asleep. There is a difference between sleep and death. From deep sleep a person awakens to resume normal activities. It is to be noted that during these two subconscious states ones involuntary activities continue. The heart beats and the digestive organs carry out their tasks. The vital breath functions but the senses for the conscious mind are not there.

Super Conscious State

It is in this state, one receives great flashes of great truths in the form of vague apprehensions which are afterward

elaborated in the jagrat, or walking State of consciousness. This state can be achieved through yoga. Through intense meditation and self control, the union of the human soul and super soul can be achieved while maintaining walking consciousness. The subject of consciousness is discussed in the Upanishads called Prasna and Manduka. It is also discussed in other Vedic writings.

Higher States of Consciousness

Since consciousness is the basis for all reality, any shift in consciousness changes every aspect of our reality. Reality is created by consciousness differentiating into cognition, environment, interaction with forces of nature, and biology. The average person only experiences the basic three states of consciousness. The brain functions measurably different in each of these states. Brain biology and brain waves show precise and different characteristics between the sleeping, dreaming, and walking states of consciousness.

Spiritual practice of Sadhna

The spiritual practices, such as yoga, transform consciousness from these three commonly known states into states of higher consciousness. Yogic practitioners recognize these as *soul consciousness, cosmic consciousness, divine consciousness,* and *unity consciousness.*

During the soul conscious state, we experience change when our integral reference point shifts from the body, mind, and ego to becoming an observer of body, mind, and ego. We experience and cultivate soul consciousness when we meditate. During meditation a person begins to identify with this aspect of self that is beyond thinking or feeling.

During cosmic consciousness one achieves an even higher awareness that is present during the walking, dreaming, and sleeping states.

Divine consciousness is a further expansion of cosmic consciousness. Present witnessing awareness is experienced, not only in silence of the self, but also in the most abstract qualities of nature and mind. These include experiences such as knowledge of the past and future known as clairvoyance. They also include a refined sense of taste, smell, sight, touch, and hearing including control of body functions such as the heart rate.

Unity consciousness is the ultimate state, also known as Brahman consciousness. It is characterized by an abiding sense of joy and peace.

Once one acquires awareness of the nature of human consciousness, it is easy to pursue the path of righteous action or karma. Bhagwat Gita is the best known treatise to understand this.

Sometimes the message is lost in excessive details. It is therefore deemed necessary to repeat that the corner stone of all righteous action are three God given human attributes or gunas known as sattvic, rajasic, tamasic.

To lead a successful life, God has revealed the necessary knowledge needed to survive and lead an exemplary life by

following the God given cosmic laws in the Vedas. They are known as the *law of cause and effect*, and the *law of energy consciousness* that is the relationship of energy and consciousness.

A process of continuation of creation using the above cosmic laws was also revealed. It is called reincarnation.

To kick start the process transcending reincarnation, the three fold path of knowledge was revealed. It had these three steps built into it.

- acquisition of knowledge
- devotion including bhakti or worship
- righteous karma

The acquisition of knowledge is stressed during first twenty-five years of one's life. Next, it was the transition into family life known as Grahisth. In this phase, the adult transitioned into becoming a bread earner while enhancing the professional and trade oriented skills. It was stressed that a low key of spiritual education was an important part of life. This was to prepare everyone for the later years when individuals had completed all the necessary and sufficient envisioned tasks and responsibilities. The next generation was now ready to lead and steer society.

One must remember that each action consists of some sattvic, rajasic, and tamasic attributes. All you need is a process to educate people to select the proper quantity of each attribute, formulating a course of action to discharge their duties. Each individual uses a different mix making their actions unique to themselves and others.

In the absence of proper exercise of these attributes, the ill thought of actions that can result in family problems. Ultimately if such actions are unchecked these lead to problems in society. These issues were adequately addressed in early Indian civilizations by setting up gurukuls. (Education centers)

Having set up a learning system, the Indian Civilization, unlike others, was able to successfully pass on the knowledge of the Vedas. This was accomplished first through the word of mouth, and later by writing. The seven Sages, or Sapt Rishi's, who received the Vedas were super souls with unique spiritualistic and materialistic God-given knowledge. This enabled them to groom multitudes of dedicated Rishi's, Sages, and scholars to propagate the preservation of the revealed word and further development of materialistic knowledge that was considered necessary for supporting obligatory duties towards society and family alike.

The gurukul methodology for education is well documented in the Upanishads. This education system served as a precursor to university systems and placed a great deal of emphasis on inquiry. The teacher-student relationship was spelled out and guru was placed in a great position of respect. At the end of the gurukul experience a message from the teacher was that the pursuit of knowledge is the real purpose of life. The student was told that his formal education is complete, however, the real learning has just begin now as you return home to your parents, take up professional duties, take on family responsibilities, and become a valuable member of your society while doing your karma.

This background is a matter of pride for the Indian civilization as it led to the most advanced civilization known to mankind. By the turn of the 12th Century, India had literally developed the technology base for industrial age that occurred hundreds of years later. It also produced Sanatan Dharma which is a predecessor of all of the world's religions.

The purpose of dharma was to assist in the day to day duties and the performance of rightful execution of dharma.

This treasure house of revealed spiritualistic and materialistic knowledge is well documented in the Vedas, Upavedas, Shastras, and Upanishads. In applying this knowledge to succeed by materialistic or spiritualistic means, a cautionary note was placed for everyone to watch out for their Ego. (Ahankar) and keep it under control. An out of control ego led many mighty and famous to their demise. Many stories drive this message home.

Ego, as a human attribute, is different than the process by which it is developed, controlled, and exercised.

The West added to the confusion when Sigmund Freud originally called it "Ich" in his physiological works which when translated into English became "I". When Western ideas and education started rewriting Indian scriptures, the Eastern thought started getting muddled. The confusion was created deliberately by the colonial powers that had a treacherous mission of colonizing and destroying India's economy. At the time of British take over, India and China represented seventy-five percent of the world's economy. It was reduced to almost nothing. India now represented less than five percent, and was reduced to abject poverty.

The spiritual Indian gurus started a crusade to regain its lost glory. They started blaming India's society ills to a rapidly degrading spirituality and value systems such as rampant greed, increasing poverty, deteriorating personal relationships, and a lot more. The primary culprit was identified to be human ego. It was stated over and over that ego must be killed if we wish to progress or seek salvation or progress on the ladder of the process of reincarnation.

Ego cannot be killed, but it can be managed to become a beneficial attribute. To acquire better understanding of this and lead a purposeful righteous life, it is important to better understand the process.

We must return to the layers of consciousness to develop a future course of our actions. There is no point in not having an "I" or ego, because without it there can be no awareness of oneself as a human being. The gifted Indian spiritual gurus have been careful to say that the real purpose is to transcend the ego. The less informed Zealots interpreted that their mission was to erase the Ego from the minds of people.

The original and correct intention was to be no longer limited and to grow beyond in an integrated way.

The conscious ego is synonymous with the conscious mind. It is not something retained with conscious mind like a floating ice cube. If you try to knock out Ego because you think it can be done by a simple surgical procedure, it will simply lead to losing state of mind. No mind. It means you have no conscious mind.

It is therefore clear that we must further understand ego. Fortunately, the depth psychologists have made considerable

strides, thanks to great inspiration from the Upanishads and other Indian Philosophy.

Ego is an integral part of human consciousness. There are three aspects of ego. They are "*I*", *Beneficial Ego*, and *Super Ego*. Ego is a concept referring to the top consciousness or pre-consciousness. These are accessible parts of the psychic apparatus provided to us by God. Part of ego organization is in the state of becoming conscious while part remains subconscious.

Ego represents what seems to be reasoning and commonsense. It is that part of the personality that is experienced as being oneself which is recognized as "I" or one's face to the world at a particular point in time.

One of the fundamental functions of ego is reality testing, or reaching into the real world to see if what is believed to be the case actually proves out.

One must remember that the above statement does not bear fruit until ego has become autonomous, thus setting one free from the conflicts between "I" and super ego.

Now let us go back to conscious and subconscious layers that were discussed earlier. Yes the ego and super ego reside in this space called the walking state of consciousness and sub-consciousness. The beneficial ego occupies a safe zone between "I" and super ego. Autonomous beneficial ego lies in this conflict free zone.

At birth we are all without ego strength or for that matter without ego completely. To be born without an ego means no there is no "I" factor. There is no enmeshment either. We came into the world still attached and enmeshed with our mother and without the ability to distinguish ourselves from

her. As we grow we start developing a sense of ourselves as we face reality. Gradually, as we grow we interact with the world we work through and the stages of ego development. The "I" factor collects all the essential data, becoming critical to the development of a reference point dealing with outside world.

As this process continues, we develop a beneficial ego which integrates and develops outputs using the "I" factor and whatever is stored in our super ego. Ultimately we become an autonomous, inner directed human being. Beneficial ego can only truly become autonomous by overcoming a super ego. The autonomous ego is by and large free from the dictates of "I" and super ego. The beneficial ego understands and integrates the energetic drives of "I" and sublimates them towards loving sexuality and creative activity. It is this autonomous ego that creates one's own moral code, making them rely on their own sense of right or wrong. Both beneficial ego strength and independence from a super ego are essential for an individual to be truly creative outside-of-the-box of upbringing, parental, and peer's standards. Super ego stands in the way of major creativity by suppressing any thought or feeling that is too unconventional or that is subject to external criticism. The selfish or big-headed personal traits often levied against ego are real traits of an underdeveloped beneficial ego.

Super ego belongs to a different frame of reference. It controls morality not ethics. It controls what one should do rather than what is right or wrong. It also controls some subconscious elements. A week beneficial ego, when not controlling a super ego, can be wild and driven by its shadow. This is not a means to valuable creativity. It can open routes to hypomania, mania, or psychosis. This can be seen in some

mystical and drug experiences and some states of passionate love.

The beneficial ego strength is the power, determination, and ability to engage reality for whatever we find it to be. We accept what is as existing and then use our cognitive, emotional, and relational skill to deal with such an ego strength that is called our inner strength. With this inner strength we tolerate stress, frustration, and deal with reality without falling back on infantile defense mechanisms.

A strong beneficial ego can tolerate difficult situations. It can cope and then we will look at it realistically and act on the solution. This beneficial ego strength is to our ability to play the game of life according to whatever curve life throws at us. The stronger this beneficial ego grows, the more of a sense of self we develop. This enhances our skills and resources to handle whatever comes our way.

In summary, if you wish to have a weak ego, the personal traits you can expect include authoritarianism, conformity, dogmatism, other-directedness, field-dependence, not tolerating uncertainty, low self esteem, and an egocentric view point. An egocentric person is self centered, has little or no regard for interests or beliefs of others than their own. Furthermore, a weak ego does not easily face, take in, or cope with reality. Instead, it fights reality, hates, and wishes it otherwise.

Expectations are unrealistic and are based on inadequate understanding. Reality seems too big, frightening, and over whelming, making one avoid encounters. We feel universally weak, fragile, and unable to cope.

Our goal should be to develop our ego to a beneficial autonomous ego state where you will display the following traits such as a strong strength of character, inner directedness, self directedness, field independence, high self esteem, acceptance of plurality of ideas, and an idiocentric viewpoint. The people that have idiocentric viewpoints value orientation, and tend to emphasize their own goals and needs. They are independent and self reliant.

We need to be very much in touch with our feelings and atman, but still remain intelligent about it so we can remain in control, and not driven by our emotions. We need a balance between left and right brain. In other words we need to retain a rational and an emotional mind with logic, intellect, and intuition. This is where mindfulness and wisdom is found.

Soul and Consciousness

Every aspect of human creation is a master piece; however the consciousness is by far the most advanced. It enables humans to bring all past credits into new life, improve on the pre assigned attributes, improve society, and continue our journey along the path of reincarnation.

During this process humans retain total control of their actions. The consciousness enables the storage of all data from our five senses provided to us by God. It also has at its disposal, the three Gunnas, that enable resolutions to all issues that mankind is confronted with. The ensuing karma can be beneficial to human family and society, or it can be completely selfish and destructive. It depends on how much Sattvic,

Rajasic, and Tamasic content was used. To some degree, the past actions govern the content. It does change as we add our own experiences and modify our decision-making criteria.

To make such a complex set of hardware and software tools work during course of our life is not totally under our control. Every element that contributes to life and its actions requires tremendous infrastructure which functions flawlessly because it is at the beck and call of our individual soul.

A great deal has been written about the soul which is our true identity.

The Upanishads state that the soul is an integral part of a super soul. It has no beginning and no end. Those who know their own soul are immortal. The soul dwells in every living being both inside and outside. The soul is sole cause of movement, but it does not move. The soul is our light of knowledge. Its light transcends brightness and darkness. The soul is a light of knowledge. Its light is also a goal of knowledge. In a soul, the subject and object are one. The concept of Brahman and Atman are ultimately the same.

These platitudes bring about the significance of one's soul. It is said that the soul and super soul are identical in attributes that merge into each other as if they are the same.

Super soul is synonymous with the creator, but the individual soul is not the creator. One might view a small piece of a gold bar as identical in properties. In this sense both represent gold and possess all the properties of gold.

The creator or super soul creates, maintains, and destroys any or all of the elements of creation. The individual soul contributes to this process. The soul receives signals from all stakeholders and transmits signals as necessary. In that sense,

it functions like a modem in receiving divine guidance. In carrying out its functions, it performs multitudes of functions in the same vein as a CEO of a corporation. Its day to day actions within humans continue without any human awareness. In my many years of corporate experience I had no appreciation for the CEO's position. It did not guide my day to day actions and did not interfere in any manner in the outcome of my actions. Once I reached the status of divisional manager suddenly I realized that without support of the CEO, our functions could not be effectively carried out.

The soul provides full accountability of our karmic life to our stake holders. It assures that our human attributes are upgraded or downgraded due to our karmic actions. All this data resides in our astral and virtual body which departs from the physical body after death. All the actions of soul are performed in compliance with the cosmic laws of cause and effect.

Consciousness works like set of software tools. It is capable of storing data gathered by the five senses and we can use it to move our reference. It brings to bear the different content of Gunnas, thus assisting decision-making under close, but invisible, control of our individual soul.

The soul constantly upgrades the data from past lives as it will be required for the startup of our next life. The hard disk can only be changed at the direction of the soul.

It was mentioned earlier that day to day human functions are carried out without awareness of the soul by humans. One such function is sustaining energy levels in various parts of the body. We take it for granted. Without the soul, the various energy centers cannot sustain causing the person to die.

The three principal energy centers within the human body include the heart, brain, and *kundalini*. The heart is the principle center of the circulatory system, the brain is the principle center of our nervous system, and the kundalini is a similar vital energy system for spiritual well being.

In the human body there are over 72,000 subtle channels known as nadis or veins.

The main subtle channels are the *sushumna nadi, pingala or surya nadi,* and the *ida or chanderma.* The sushumna nadi is the central channel that extends from the base of spine to the top of head. The pingala or surya nadi is the channel that runs to the right of the sushumna nadi. The ida or chanderma is the channel that runs left of the sushumna nadi.

The vital energy, the active chetana or prana shakti, is transmitted in the body through a surya nadi, chandra nadi, and many other smaller nadis. Kundalini is the spiritual energy that generally lies dormant coiled at the base of sushumna nadi for the average person. Through spiritual practice, it begins to rise from the base of the spine through the sushumna nadi until it reaches the top of head.

When the Kundalini reaches the sahasrara chakra it stays there permanently. We call it enlightenment. This is where union with God occurs.

Chetna is the supreme primal energy also known as a soul. Panchabuta (ether, air, fire, water, and earth) and panchendriya (sight, hearing, smell, taste, and touch) hold the body together, but it is the supreme primal energy of the soul that makes them perform their functions. It is in charge of all driving hardware and software functions. Therefore chetna is the driving energy behind the sustaining of life. When the

soul leaves the body, we declare that the soul has left the body or death has occurred.

Panchendriya are the tools that give us ability to recognize the physical world around us They restrict our information to their range of sensitivity which has only a limited range. The sound we hear is between the frequency of twenty and two thousand cycles per second. Ultrasonic is far greater than this limited range. We see only one fifth of electromagnetic radiation. Only the **VIBGYOR** range is visible which stands for violet, indigo, blue, green, yellow, orange, and red. The infrared is felt as heat and ultra violet, x-rays, and gamma rays are not seen even though their effects can be felt.

What we hear, smell, taste, or touch is within a small range just sufficient enough to sustain our life. The range beyond our sensibility is very vast. The more science is beginning to look at mysteries of materialistic and spiritualistic world, the study of soul and consciousness will become the center stage of future scientific developments. It holds the hope that that outcome will serve the well being of mankind if the knowledge is protected and managed in a responsible manner.

RELATIONSHIP OF CREATION AND KNOWLEDGE

This is a subject that has preoccupied mankind since its inception. Most civilizations have very little to say. The Judeo-Christian and Islamic view is stated in the Old Testament in its first chapter entitled Genesis. The narrative is very brief, covering less than a page. It is hardly an unambiguous view of the origin of the universe. This very simplistic view has been challenged by scientists. Early western scientists paid a price with their lives when they challenged this view.

According to Genesis in the Old Testament, *God is believed to have created the universe in six days. Each day certain things or forms of life were created. Finally, on the 6th day, God had completed his task. He created heaven, earth, known species of life, and things ordinate and inordinate. On the 7th day God rested.*

The Vedas provide the timeline of creation. The creation is described as many galaxies. The cyclic nature of the universe's galaxies is also described. Some galaxies are being created while others are being destroyed.

Four Yuga's are described that relate to our lives on earth. They are

- Sat Yuga (40%)
- Treta Yuga (30%)
- Dwapara Yuga (20%)
- Kali Yuga (10%)

During each of these yugas, the degree of good and bad changes. Sat Yuga is where everyone is virtuous. In Treta Yugas, three fourth of the deeds are virtuous. In Dwapara Yuga, an equal amount of good and bad exists. We are currently in Kal Yuga where evil deeds begin to dominate.

In the Veda's version of creation the supreme consciousness decided to create the universe from preexisting matter, utilized its super energy. The creation was carefully created with different degrees of consciousness, and in this manner it kept eternal contact with its creation.

While each of the species are provided a varying degree of freedom, the capability of each species differs.

Cosmic laws were also established to sustain the universe and control the behavior of all species.

According to the Vedas, the creation of universe is shrouded in mystery.

The Rig Veda States that *there was not existence or nonexistence, there was no realm of air, and no sky beyond it. What covered in and where? Who knows then whence it first came into being? The first origin of this creation, whether he formed it all or did not form it. Whose eye controls this world in the highest heaven, he verily knows it, or perhaps knows not.*

According to the Upanishads, the universe including Earth, humans, and other creatures undergo cycles of creation and

destruction. Puranas also assert that cosmos are eternal but cyclic.

Indian cosmology and time lines are closes to modern scientific timelines. It also supports the view that the Big Bang theory was not the beginning of everything, but could perhaps be the start of a cycle that is preceded by an infinite number of universes, and followed by another infinite number of universes.

Modern science's Big Bang theory has almost bit the dust as it violates several cosmic laws. In addition, it poses a singularity problem and violates second law of thermodynamics. Science has not been able to create consciousness or explain it. Western science has had remarkable success in explaining the functionality of the materialistic world, but when it comes to the inner world of mind, it has very little to say. In general, when it comes to consciousness itself, science falls curiously silent.

Before Creation

There are seven hymns in the Rig Veda relating to the formation of creation. They are separate visions. Each one has a particular aspect of a problem as its content. They provide abundant material to be woven together in the fabric of creation.

If taken collectively, we can easily create a clear, coherent, comprehensive, and convincing theory of cosmology.

The first hymn talks of the beginning of creation and this begins by stating the state prior to all existence, previous to

evolution. Furthermore, it gives details of the potentialities and dimensions of the will to create in action.

To the unthinking mind, there was obviously nothing but a mere nothingness. On the other hand, this hymn declares that there was neither existent nor nonexistent.

This seemingly paradoxical statement is vital to a correct understanding of the process of creation. At the same time, it is central to the most fundamental principle of Vedic philosophy. We find reference to it in Vedic philosophy and the Bhagwat Gita.

The hymn indicates that in the beginning there was not existent sat. In its manifest aspects, the universe of the name and form sat did not exist as such then. To avoid the possibility of misinterpretation of this term, the hymn adds straightforwardly that there was nothing like unlimited nothingness either. It is asserted in the same breath that nor was there nonexistent. It is not nonexistent, for it is a positive being from which the whole existence springs into being. The hymn asserts the reality and existence of the "One" that breathless breathed by itself. The "One" breathed breathless by itself, by self impulse or innate infinite power. Other than that, there was nothing whatsoever. (R10.1292).

Who Was That One

The hymn reveals the presence of the "One" preexisting and self existing Reality. (R1.1.1.)

It is wonderfully portrayed and mystically worded as neither existent nor nonexistent. It is the perfect vision of the

absolute reality. The supreme being is both indeterminable and indefinable. He is indeterminable because he is neither being nor non-being.

He is non-being since he is in corporeal. He is being since he is possessed of Tapas infinite vital force. He is indefinable, since no term which we use for defining an object can grasp his infinity.

On the other hand, he is portrayed as personal with a self conscious being. He is the very source and essence of all existence. The supreme being exists in a state of eternal repose and quiescence, poetically any mystically described as neither existent nor nonexistent. He is nonetheless capable of eternal action and creation.

The seemingly passive or inactive being becomes an active, creative person—the creator of all that exists.

Creation Out of Chaos

He created the cosmos out of chaos. In the beginning, darkness was veiled in gloom profound, and all this was indiscriminate chaos. One which was covered by the void, through the might of Tapas, the conscious vital force of energy, was manifested. Mighty in mind and pervading, Vishvakarma, the maker and disposer, was the loftiest presence omniscient of all seeing. His aspirations find fulfillment in delight supernal where the one, and only one, is beyond the Seven Rishi's Starry Heavens. These Rishi's were designated prominent place in the sky among the stars. (known as the Big Dipper in the West)

The Absolute Nirguna Brahman, or attribute-less reality, becomes Saguna, or the eternal with infinite attributes.

He is revealed as a finite-infinite person and the cosmic man who was the creator of all things existing today. He is also the lord of all created beings and their actions known as Prajapati. The supreme being assumes all these attributes and forms in order to accomplish the process of creation.

Four Stages of Creation

- Hymn (R10.1293, R10.1294, R10.1295) contemplate the development of the concept of Vedic cosmology in four well ordered stages. We have first the vision sublime of what existed before the process started. The hymn points the existence of supreme being as absolute reality. He is described as indefinable. He is indeterminate, yet expressed in mystic terms as neither being nor non-being which was already stated earlier. He is the nature of pure consciousness.

- He is next envisioned as self consciousness-a conscious being conscious of its own. Its termed as Tapas which means the innate infinite vital creative power. The supreme being created the universe through his power, acting on eternally pre-existing matter of which was constituted the material for bringing creation into existence. (R10.1293)

- Tapas then assume a creative form in the shape of Kama which is the desire or will to become. Kama constitutes the secret of being of transforming itself

or assuming the form of becoming. It is the first seed of self consciousness. There was Kama aroused in the beginning which was the primal germ of the mind. The Sages searching in their minds and hearts with wisdom found in existence as the kind of existence. (R10.1294) The Tapas were directed towards energizing its activity of creation by a conscious will to become. Within the super being, he has the impulse or will to project himself into the world of diversity. Kama gave a concrete shape to what was a mere abstract existent that was infinite in extent and power.

- The rays were stretched across transversely or obliquely. (The will was there always in the infinite). Creation started with rays of light and rays of activity. The rays of activity began to spread out all around. What was below it and what was above it? The divine structure of the universe, like threads of fabric, or like rays of the Sun, spread below and above on all sides. There were the seed bearers, and there were the mighty forces or life-giving powers and principles. It represented the impulses from below, the forward movement beyond free action at one place below, energy at another above, nature below, and will above. (R10.1295).

The Svetasvatara Upanishad addresses the question pertaining to cause of universe.

Usually, there are mainly two causes for creation of anything. One of the two causes is material and the other is usually efficient. Material cause deals with the materials constituting an object of creation. Efficient cause deals with

the instrument or the subject that brings the creation into existence. These are objective and subjective causes. For example, for the creation of an earthen pot, clay is the material cause, but the potter is the efficient cause.

The students wanted to know if time was cause or if it is the very nature of things that caused the universe? Did the universe come into existence by some mysterious working of destiny? Has the universe been brought into existence by the coming together of the elements? Could it be combination of all those things as the cause of universe? After examining each cause separately and conjointly, they came to the conclusion that none of these factors could be the cause of the universe.

The earthen pot cannot come into existence just because there is a lump of clay lying around. There has to be a potter to use the clay for the creation of the pot. They found the absence of the potter in all the above factors.

After eliminating other factors, such as the soul that is subject to pleasure and pain, they soon zeroed in on the absolute-God. Alone he is without limitation.

It is affected by neither time, necessity, nor other material or psychic elements. The absolute, or supreme being, is the cause. All else is the effect.

After considerable discussion of cause and effect, and how it relates to human struggle resulting in endless sorrow and suffering, one could conclude that if only man could see the cause in the effect, the intangible in the tangible, Brahman in the Universe, and the creator in creation itself, then all endless sorrow will come to an end.

When man discovers undistorted self in the world, then does he know Brahman, the ultimate and the un manifest?

Primary matter is perishable. Self is immortal and imperishable. Over both the perishable and the Self, it is Brahman that presides. By meditating on him, by union with him, and by entering into his being more and more, there is cessation from all illusion.

Man has always been curious to know how the universe was formed.

The Vedas answer is that God in his super conscious state, using preexisting matter that existed in a different form, created the galaxies which included planet Earth. The creation is akin to an expanding or shrinking egg. It depends on creation of matter and anti matter. Excess causes growth, and shortfall ends in shrinkage of the egg. The creator stays outside the egg.

The knowledge of the working of the galaxies and solar system that governs us was necessary for our existence as well as our well being. The characteristics of these planets, their interaction, and their impact on us were questions that needed answers.

Early man even wondered to themselves where the sun went after the sunset and what caused rain or other weather conditions to prevail. It was essential to them to comprehend the understanding of the absolute, or God, from day to day life. The absolute, including our purpose on Earth, was another unknown. The Vedas provided all the necessary answers.

Since the Vedas were composed in cryptic verses, it demanded considerable inquiry to understand the deeper meaning of all that was disclosed.

God was described in the super conscious state when he created the universe. This state is the manifest state of energy. God created man in his own image and therefore, it is all about energy. By providing suitable wiring,

Receivers, and transmitters the supreme being could keep in touch with all of us, furthermore controlling our actions if need be. Similarly we can exercise our freedom. We can seek guidance!

The supreme being has bestowed humans with knowledge for their progress and well being. This knowledge was given at the time of creation through the Vedas.

Having read many books on the Vedas and Upanishads, it is easy to be overwhelmed by the hymns in praise of Agni, Indra, Vayu, etc.

God created many galaxies. Our galaxy is just a minor part of his creation. As a subset of that, planet Earth is even a smaller part of our galaxy. Humans are created to coexist with many other species and in harmony with nature.

One must remember that it was necessary as a first step to early progress to fully understand the attributes of nature, and have due respect for all the forces of nature. These forces of nature control everything we need including food. To grow food we need water, heat, earth, and ether.

The Vedas cover vast knowledge that we need to know for our spiritualistic materialistic well being.

The Vedas teach in short or in detail a wide range of knowledge necessary to steer through the complexities of life including some of these terms below that were

discussed in chapter two and are repeated here for the sake of convenience.

- Action and Devotion
- Yog (union with God by the means of thought and meditation)
- Righteousness
- Wealth
- Desires and Salvation.
- Parigrah (what to accumulate)
- Tyag (what to give up).
- Preya (actions which are appealing to follow but are the cause of suffering in the end)
- Shreye (the path of righteousness which is difficult to follow, but leads to eternal happiness.
- Bhautik, Daivik, and Adhyatmik (material relating to nature and spiritual being)

Human life and means of its progress and development

There is nothing related to human life, materialistically nor spiritually, which has not been referred to in the Vedas. Swami Dayan and Saraswati have both stated that the Vedas deal with four classes of subjects which are:

- Jyan (knowledge in general)
- Karm (action in general)

- Upasana (communion with God)
- Vijayan (philosophy or metaphysics)

Jyan is the first subject of the Vedas. The Vedas are a storehouse of two kinds of knowledge which are materialistic and spiritualistic. The origin of astronomy, mathematics, medical science, physics, botony, zoology, and other subjects is found in the Vedas.

This knowledge is very broad and applies to our progress as human society, our coexistence in nature, and with other species.

Karm means all types of actions whether they are physical or mental and with or without a desire for any reward. The Vedas teach all these, and explain in short or in detail all aspects and needs of human conduct which may be helpful in making the human life cultured and up lifting. Celibacy, education, student-teacher relationships, married life, social order, politics, administration, discipline, governance, charity, goodwill and co-operation, all have been explained in the Vedas. Emphasis has been laid on unity between physical and mental actions as well as knowledge and action. The Vedas instruct humans to attain all the four objects of life which are viz righteousness or dharma, wealth or arth, fulfillment of desires or kaam, and salvation or moksha.

Upasana means meditation and communion with the almighty God. The Vedas have laid emphasis on the worshiping of God.

Vijayan or meta physics is the realization or acquiring of correct knowledge of all things ranging from the almighty God to the ordinary blade of grass and tiny insects. Vedic

philosophy deals with the nature of existence, truth, and knowledge.

The Vedas contain all the knowledge for righteous living. The knowledge is given in the form of cosmic laws or in the form of formulas. The Rishi's developed additional knowledge on the basis of this knowledge. Similarly, various weapons, transmissions, and other technical things have been developed on the basis of these. There are few formulas that govern the universe.

These are called ritam. For example, formulas that remain constant, such as sunrise, sunset, day, night, and so on. It depends on us to develop them further.

The revealed knowledge was intertwined since the beginning. Instead of covering materialistic knowledge that we use every day as a part of creation, I chose to devote a separate chapter to it early on.

Another reason to separate this was to make sure that readers understood that the Vedas is not all about hymns and meditation, but it is about leading a wholesome life, doing righteous actions, and staying in touch with God through meditation. The Vedas include faith and reason. They explain the fundamental laws of the universe which is nothing but science. No wonder all the revealed knowledge in the Vedas has stood the test of time and the scrutiny of modern science.

PEARLS OF WISDOM FROM THE UPANISHADS

The Upanishads are a record of inquiry that has continued for thousands of years after the Vedas were revealed. It took every element of revelation and challenged it. During the process, a much more profound and clear view of revelation emerged and vindicated all the revealed truths. Those interested in pursuing their own studies might consider reading some of the Upanishads such as

- Kena Upanishad—discusses curiosity vs. inquiry and contains the How? What? And Why? discussion
- Isavasy Upanishad—discusses knowledge, values, and immortality
- Khandogya Upanishad—discusses what is better than what
- Svetasvatara Upanishad—discusses the creator
- Prasna Upanishad—discusses the unconscious, subconscious, and super conscious stages of consciousness
- Mandukyu Upanishad—same as Prasna Upanishad
- Taittirlya Upanishad—discusses human relationships, responsibilities, and effective communications

- Aitareya Upanishad—discusses creation of the universe
- Katha Upanishad—It provides the significance of Om and the secret of death

Some of these subjects have been briefly covered in previous chapters. I have selected some brief statements that will provide an insight into the nature of inquiries that were undertaken.

The one central theme underlying in all the Upanishads is that Brahman and the atman are identical. The nature of Brahman resides in the atman. There can be no difference between the two. If they differ in quality then surely the atman can never know the Brahman. The built in receivers and transmitters in human consciousness permit correspondence between true devotees and Brahman. A devotee is in touch with their atman when the atman sensors are turned on. Most humans go through life without being in touch with their atman. Since the quality of things is indivisible, the quality of the Brahman must reside everywhere.

In the Isa Upanishad, it says *covet not the wealth of another.* The wealth of another obviously means the wealth that is not given to you. Why does one covet another's wealth? It is because one has not discovered their own treasures. Another quote from the same Upanishad says *he who knows both knowledge and action, with action overcomes death and with knowledge reaches immortality.*

In the Kena Upanishad, the teacher encourages students to ask as many questions as possible; however he cautions that they must keep in mind that there is a difference between

curiosity and inquiry. A state of inquiry constitutes a healthy condition of the human mind. The curiosity arises from a shallow and superficial mind. Inquiry on the other hand emerges from the depths of human consciousness.

A deep inquiry is fundamentally concerned with three questions. They are known as the how, why, and what.

All scientific inquiry, whether covering the physical or the occult sciences, relates itself to the question of how.

Science is always concerned about finding out how things behave.

Philosophy has its inquiry turned in a different direction. It is interested to know why things behave in a particular manner.

Mysticism, or religious experience, is not satisfied with merely the how and why. It wants to find out what is behind all patterns and motivations of behavior.

At the core of human actions there are three Gunnas that have been discussed earlier. These are Tamas, Rajas, and Sattva. The Kena Upanishad states that in Tamas, Rajas, and Sattva we are concerned with the problems of unrighteousness, righteousness, and self-righteousness. Respectively Tammas is a condition where mind is too lazy to differentiate between the right and the wrong.

There is nothing more unrighteous than a confused state of mind. In Rajas, there is a struggle between the right and wrong. It is a struggle of the mind to establish supremacy of what it regards as the right. Sattva represents a temporary resolution of the conflict resulting in self-righteousness. It gives the mind a sense of power and ruler ship along with

a sense in which it feels it can keep the two opposites under control.

The Kena Upanishad covers knowledge in great detail. To know what knowledge explains, and to know what knowledge does not explain, this is the highest state of knowledge that a mind can go.

It states that knowledge of the Gods is to be understood as knowledge gathered through super physical means.

Khandogya Upanishad

The Khandogya Upanishad takes on the subject of what is better than what.

- Teacher concedes that there is nothing better than name and who meditates on the name as Brahman. (God)
- The student pursues his inquiry . . . What is better than name? The teacher states that speech is better than name because it enables us to understand what was revealed in the Vedas. For if there was no speech, right or wrong would not be known and neither would true or false, good or the bad, and pleasant or unpleasant. So the teacher says meditate on speech.
- Next the teacher states that mind is better than speech. The mind holds both speech and name. For mind is indeed the self, mind is the world, mind is Brahman. Meditate on the mind.

- Will is better than mind. When a man wills, then he thinks in his mind, then he sends forth speech, and he sends it forth in a name.
- Consideration is better than will. For when a man considers, he wills, then he thinks in his mind, then he sends forth speech, sending it forth in a name.
- Reflection is better than consideration.
- Understanding is better than reflection. Through understanding we understand the revealed knowledge and the rest follows.
- Power is better than understanding. One powerful man shakes a hundred men of understanding. If a man is powerful, he becomes a rising man. If he rises, he becomes a man who visits wise people. If he visits, he becomes a follower of wise people. If he follows them, he becomes a seeing, a hearing, a perceiving, a knowing, a doing, an understanding man.
- Food is better than power. If a man abstains from food for ten days, though he may live, he would be unable to see, hear, perceive, think, act and understand.
- Water is better than food. Without water there will be no food.
- Fire is better than water. Without it there would be no lightning, thunder or rain.
- Ether is better than fire. For in exist both in the Sun and the Moon, and furthermore in the lightning, stars, and fire. Through ether or space we are born.
- Memory is better than ether. Without memory no one will hear, perceive, or understand.
- Hope is better than memory.

- Spirit is better than hope.
- The highest is true or the almighty God.

The teacher exposes the student to many blessings of God. One learns to respect the power these hold on us. Our knowledge of these bestows power to us.

Taittiriya Upanishad

It provides a detailed description of the gurukul system of education. Both types and methods of education are discussed. The task of Gurukul teachers was to awaken intelligence among his students. The students that came out of gurukul education systems were inquirers. Their process of inquiry never ended.

The teacher placed a great deal of emphasis on the use of the five senses. Particularly, emphasis was placed on listening since that was the key of learning for the student, and speech since that was the key for the teacher to successfully convey the subject matter. Learning correct pronunciation and emphasis on learning to speak correctly led to early discipline. The same emphasis was placed on language.

In the process of gurukul education the students were exposed to their duties towards themselves, parents, society and the world at large. As they graduated, besides acquiring professional skills, they were prepared to start their own families. Their role as bread winners was explained to them. Human relations were not left out.

Brahman comes to the thought of those who know super consciousness as beyond thought, not to those who imagine super consciousness can be attained by thought. Brahman is unknown to the learned and known to the simple. Super consciousness is known only to the simple. The simple are those who are free from the burden of mind's accumulations. Another way to look at it is that it is known only when the mind is free from its three attributes called Tamas, Rajas, and Sattva. It is only the meek that shall inherit the kingdom Of God.

Notice that Jesus also said covet not the wealth of another. There are many quotes that were found in the Upanishads thousands of years earlier. This supports the fact that Jesus was aware of the wisdom of the east and divinity of Indian spirituality.

Katha Upanishad

The Katha Upanishad states that it is not belief in reincarnation or the immortality of the soul that can liberate mankind from the specter of death. Man must know the secret of death. This is secret known to none other than death itself.

What is actually in the moment of death being or not being?

Wisdom is not the opposite of ignorance. Wisdom has no opposite. It arises when both ignorance and knowledge are negated. Obviously the path of wisdom is one where man becomes lighter having shed all his possessions, and it is therefore able to swim easily in the current of life. It again

reminds one of the rich men who wanted to seek the kingdom of heaven and was willing to pay any amount to Jesus. Jesus responded that *the rich man must first get rid of his ill-gotten fortune.*

When the wise rest their minds on God that is beyond time, hard to be seen, and dwelling in the mystery of things, then he rises above joy and sorrow.

This brief selection of some notable quotes are intended to tempt the reader to read more, know more, and become a champion of knowledge materialistically and spiritually. A good selection of the Upanishad translations are now available by learned Indian authors. I have found them more rewarding than western authors who seem to miss the mark as they are not familiar with Indian psyche.

The sacred word "OM" is considered as the generalized symbol of all possible sounds. One of the explanations given of three letters A.U.M. is that they represent creation, preservation, and destruction respectively. The significance of "OM" lies in not what is uttered, but in what remains un-uttered. It is not articulate, but it is inarticulate sound that holds the key to understanding of the sacred word. The mystery of beyond lies in the Great Word "OM", but the mystery can be unraveled not in the articulate, but in the inarticulate nature of the sound. "OM" is equated here with Brahman.

Finally, it is indicated that the great secret of death lies in the atman and nowhere else. In order to know Brahman, one has to know the atman.

The catch is that through studies the mind cannot know it. What is to be done? The Atman reveals itself that it cannot attained. It reveals itself in only those whom it chooses. It

obviously means that atman cannot be sought by the human mind! It comes! One cannot go to it! When everything drops away, even the seeking of the atman, then into that consciousness, pure and unsullied, the atman reveals its own nature.

So many things that we seek spiritually end up under the Golden Veil over our consciousness. It is the most significant revelation. Read the chapter on consciousness over and over. Then read on commentaries of Deepak Chopra and a great yogi of our times named Paramahansa Yogananda—the author of "Autobiography of a Yogi" and founder of the Self Realization Foundation in the USA. Until one grasps the significance of Consciousness, it is impossible to comprehend this gift of God. It is through this consciousness that we carry out our karma using the three Gunnas. (Tamas, Rajas, and Sattva)

When one dies are the remains just dead a body bereft of life? Where does life go? The subtle body that encloses the atman never dies. It moves on to seek the next assignment of God in the hereafter. Ordinarily, man returns to fresh birth after death. There is also the possibility of man going to the region of the imperishable, and thus be freed from the necessity of rebirth.

He who knows the atman while living knows the meaning of the Manifest and also the secret of the Un-Manifest. (See the chapter on Reincarnation).

The term Tapa is used in the chapter on Creation. Tapa is the process of sorting out the essentials and the nonessentials. It is the denial of the nonessentials. The denial brings about a release of energy. With the release of energy one faces a new

problem—one with conservation of energy. (A cosmic law of note)

The sages often repeat that as humans we have much in common with the rest of creation. We are all made of the same five elements. A body kept together merely by five elements is a house engulfed in darkness.

Who keeps the body vibrant? One might say it is the built in body hardware such as different body parts, and their capabilities that are pre-programmed. All these functions stop working when a person dies though because the body does not possess any consciousness and is bereft of the atman that has moved on with the subtle body.

Manduka Upanishad

The Prasana Upanishad and Manduka Upanishad provide valuable insights into workings of consciousness. (See chapter on Consciousness)

Reincarnation may be viewed as a process of the preservation of human life, its continuity, its refinement, and assuring well being of society by keeping a good value system intact despite of all the tamasic temptations.

Consciousness and its development through thirst for knowledge, meditation, and filling the consciousness data bank with all the good deeds and ideas of what is better, what is noble, and what is in every one's interest. The Upanishads provide a storehouse full of such knowledge, making the task easier for us all to safely cruise through sea of life.

The Mundaka Upanishad also provides a discussion of differences between wisdom and knowledge. It states that wisdom cannot be attained by the extension of knowledge. It must be remembered that wisdom and knowledge belong to two different dimensions.

This Upanishad also discusses the difference between higher and lower knowledge. The knowledge gathered from sacred books does not become sacred or higher. It is not the sacredness of a book that matters. What matters is the sacred approach. The word sacred means that it is inviolate or inviolable. Therefore, what is sacred is uncorrupt or incorruptible.

Lower is the knowledge of immanent, and higher is the knowledge of the transcendental. It also states that happiness that is dependent upon external factors is bound to be short lived. Another statement proclaims that man of sacrifice and humanitarian works enters again and again in this world. One who pretends to be holy or one who thinks they can become holy by observances of outer practices, whether they are sacrificial nature or of a humanitarian nature is only fooling himself. When the end is pure, the means will become pure naturally—almost effortlessly.

To see the creator in creation is indeed to come to higher knowledge.

In various religious books such as the Bhagvad Gita and the Upanishads the three paths are mentioned. They were the path of knowledge, the path of devotion, and the path of action. There are no three distinct paths from each other. These three together form the whole spiritual life. I have always considered an Upanishad that draws from the best of all that

Upanishads have to say. A reader of Gita, who grasps and performs the correct karma, is blessed indeed. Devotion is the meeting place where both knowledge and action both meet. That is where God resides. God can be known by the act of complete surrender. Surrender is indeed a total action where there can be no reservations attached. It is the path of knowing God. Wherever a man acts totally, without any reservation, he comes to the experience of this Supreme Being.

The Upanishads were a product of free inquiry. Between the teacher and student there was a relationship of complete understanding and cordiality. In the Upanishads, one sees the truth of statement. It is not the conclusion that matters. It is the process by which conclusion is arrived at. To utilize reason in order to show the inadequacy of reason is a difficult undertaking, but teachers of the Upanishads have displayed a remarkable mastery over this technique of transcending the mind with the help of mind.

It is through the Upanishads that Persians, Greeks, and Egyptians have acquired the concept of Dharma which later became the foundation of their thinking and religions.

SANATAN DHARMA

As the society received the gift of knowledge through the handpicked Rishis, it proceeded to preserve it for posterity. The various Rishis led the way to set up gurukuls and they received patronage of the early rulers. The population was not too huge and these centers were set up outside the hustle and bustle of the urban area. Eventually, this student-teacher system evolved into a university system. The education system was unique in the fact that it devoted time to teach dharma, or a value system, to tackle obligatory duties of life and selected individual curriculum based on aptitude. The broad education included sciences, mathematics and arts including philosophy.

The sacred scriptures such as the Vedas, Upanishads, and Puranas were not only taught, but they were debated upon for the sake of retaining the spirit of inquiry. Individual views were valued. The code of conduct value system that was developed, regulating the society at that time in antiquity, is commonly known as Sanatan Dharma. Sanatan Dharma spread from India to countries such as Persia, Greece, and Egypt. It even extended into East Indonesia and Mesoamerica.

Sanatan Dharma is, by its very essence, a term that is devoid of sectarian leanings or ideological divisions. The two words Sanatan and Dharma come from the ancient Sanskrit language. Sanatan denotes the meaning of beginning-less, endless, does not cease to be, that which is eternal, and

everlasting. The term Dharma, with its rich connotations, is not translatable to any other language. Its approximate meaning is natural law, or those principles of reality which are inherent in the very nature and design of the universe. Thus, the term Sanatan Dharma can be roughly translated to mean the natural, ancient, and eternal way.

Sanatan Dharma does not denote a creed, but it represents a code of conduct and a value system that has spiritual freedom as its core. Any pathway or spiritual vision that accepts the spiritual freedom of others may be considered part of Sanatan Dharma.

First and foremost, Sanatan Dharma is without beginning and without a human founder. It is defined by the quest for cosmic truth, just as the quest for physical truth defines science. Its earliest record is the Rig Veda. The Rig Veda is the record of the ancient Seven Sages who were selected by the divine or super consciousness to transmit the truth about the universe in relation to mankind's place in relation to the Cosmos. They saw nature, including all the living and non-living things, as part of the same Cosmic equation and as pervaded by a higher consciousness. This search has no historical beginning nor does it have a historical founder.

The Nature of Sanatan Dharma

By its nature, Sanatan Dharma is:

- God-centered rather than prophet-centered
- Experience-based rather than belief-based

- Beyond any historical date of founding
- The process of growth which comes from the seed
- Inherent in and inclusive of all
- In the world while above the world
- Both immanent and transcendent
- The whole and the parts
- Loving of all and excluding of none

The basic principles of Sanatan Dharma are:

- Sanatan Dharma recognizes that the greater portion of human religious aspiration has always been unknown, undefined, and outside of any institutionalized belief.
- The universal law of Dharma, regardless if you call it Dharma or something else, has eternally existed. It has been in existence before any of the great teachers were born. It is not better than or alternative to, but it is inclusive of all. Dharma is that of which earth and humanity itself emerged. Dharma not only was, but is and always will be in existence. To live in alignment with, and to know the true nature of that Sanatan dharma is one of the ways of describing the higher goal of life
- Sanatan Dharma gives reverence to individual spiritual experience over any formal religious doctrine. Wherever the universal truth is manifest, there is Sanatan Dharma, whether it is in the field of religion, art, or science, or furthermore, in the life of a person or community. Wherever the universal truth is not recognized or wherever it is scaled down or limited to a particular

group, book, or person, even if it is done in the name of God, Sanatan Dharma ceases to function.

- Sanatan Dharma is comprised of spiritual laws that govern the human existence. Sanatan Dharma is to human life as natural laws are to the physical phenomena. Just as the phenomena of gravitation existed before it was discovered, the spiritual laws of life are eternal laws existed before they were discovered by the ancient Sages during the Vedic period. Sanatan Dharma declares that something cannot come out of nothing, and therefore the universe itself is the manifestation of the divine being.

- Since Sanatan Dharma is referring to the ways of being that are in concert with the absolute, therefore being axiomatic laws, this term is not referring to something that is open to alteration. Just as the laws of gravity, mathematics, or logic are not open to sectarian debate or relative opinion, similarly, the subtle laws of God transcend all partisan concerns. (For example gravity is an inherent law of nature regardless of whether one believes in the law of gravity or not)

- The world is made up of three tendencies called gunnas. The three gunnas are Sattvic, Rajasic, and Tamasic. Sattvic tendencies are those that are pure, clean, good, wholesome, calming, and peaceful. Rajasic tendencies are those that are active, moving, decisive, and forceful. Tamasic tendencies are those that are inert, lazy, dull, and evil. If it was not for these tendencies, we would not exist. Every single action or decision is a mixture of these gunnas. Even a Saint who is primarily Sattvic

has some level of Rajas and Tamas in him/her whether they are big or small.

- Sanatan Dharma makes use of yoga as a means to attain Moksha. Yoga has been poorly translated to mean union. It does mean union, however, that is a poor definition as yoga truly encompasses much more. Yoga is union with Brahman-the absolute God. Yoga is a route to achieving union with Brahman. The word Yoga is not merely a statement of union, but it encompasses the actual experience of liberation.

Sanatan Dharma has been called the cradle of spirituality and the mother of all religions partly because it has influenced virtually every major religion.

With its origins in antiquity, it is a way of life that encompasses all aspects of life including family, social life, sciences, politics, business, art, and health behaviors.

The sacred scriptures contain instructions on these aspects of life and have a strong influence on art and drama. While the ascetic practices of yoga are well known aspect of Sanatan Dharma worldwide, family life is considered a sacred duty.

Origin

Sanatan Dharma has origin in such a remote past that it cannot be traced to any individual. It is not founded by any single event or prophet, but it precedes recorded history. Some scholars view that it may have existed long before 13,000 BC. The timeline is being revised in the light of a recent discovery

of a legendary city called Dwarka. It was called the Golden City Of Lord Krishna and it sank around 13,000 BC. According to the Mahabharata, It sank after the Battle of Mahabharata and the death of Lord Krishna.

In terms of Indian history, Sat Yuga, Dwapara, and Treta Yuga precede Kalyug which started after the Battle of Mahabharata. The history and life of those periods is well recorded in the Ramayana and the Puranas. Timelines were blurred as the colonial powers tried to ridicule India's claim to its antiquity.

The recent discoveries include Ram Setu which is a manmade bridge running from Rameshwaram, India to Ceylon, or present day Sri Lanka. The underground discovery of the lost Sarswati river, which is repeatedly mentioned in the Vedas, and the discovery of the legendary sunken city called Dwarka, by NASA and ISRO satellites. All these are discoveries that restore credibility to India's claim as the oldest and most advanced civilization on planet earth.

Sanatan Dharma: The Timeless and Universal Way

Sanatan Dharma is the eternal and universal law, or principle, that governs every irrespective of culture, race, religion, belief, and practices. These truths regarding the universal principle were divinely revealed to ancient Sages, and they are now recorded in the Vedas. For many eons they were orally passed down. Much later they were written down.

Sanatan Dharma is to human life as natural laws are to physical phenomena. It encourages its followers to seek spiritual and moral truth wherever it might be found. No creed can contain such truth in its fullness, and each individual must realize this truth through their own systematic effort. Our experience, reason, and dialogues with others, especially with enlightened individuals, provide various means of testing our understanding of spiritual and moral truth. Ultimately truth comes to us through direct consciousness of God or the ultimate reality.

Concepts and Teachings

The best way to understand Sanatan Dharma is through its teachings. It rests on the spiritual bedrock of the Vedas, Upanishads, and the teachings of great Sages through the ages.

One feature unique to Sanatan Dharma is its assertion that Moksha (liberation or deliverance) can be achieved in this life itself. An individual does not have to wait for a heaven or death. It guides people along paths that will ultimately lead to Atman and become one with Brahman. Sanatan Dharama recognizes that everyone is different, having their own unique intellectual and spiritual outlook. It allows people to develop and grow at their own pace by making different paths available to them.

Brahman: The Ultimate Reality

Brahman is the ultimate reality or super consciousness that created us all. It is perceived as formless, un manifested, and manifested with attributes such as Omni-present and Omni-powerful.

Brahman, Vishnu, and Shiva

These are the three manifestations of God as perceived in Sanatan Dharma. *Brahman* corresponds to the creative spirit from which the universe arises. *Vishnu* corresponds to the force of order that sustains the universe. *Shiva* corresponds to the force that brings a cycle to end destruction. Shiva acts as a prelude to transformation leaving pure consciousness from which the universe is reborn after destruction.

Any of these manifestations may choose to take birth in a knowable form such as Avataras or Incarnation. Krishna and Rama are notable Avataras of Vishnu who were born to uphold Dharma or restore balance to the world.

Ishvara is the personal aspect of God. When people pray not thinking about attributes of God, they view God as their guide. *Devatas* are the celestial beings. The Vedas and other literature pieces speak of many celestial entities called Devatas. These Gods perform a divine purpose at the beck and call of God. Some people may worship them as their personal preference. The worship of the Consorts of Brahman, Shiva, and Vishnu are revered and worshiped by many. All the devotees believe in only one eternal God of everyone.

Samsara: The Chain of Lives

We normally think of ourselves as coming into being when we are born of our parents, and as perishing when we die. However, according to Sanatan Dharma present life is merely one link in a chain of lives that extends far into the past and projects far into the future. The process of our involvement in the universe and the chain of births and deaths is called Samsara. Samsara is caused by a lack of knowledge of Atman and our resultant desire for fulfillment outside of us.

We continue to embody ourselves, or be reborn, in this infinite and eternal universe as a result of these unfulfilled desires. The chain of births lets us resume the pursuit. The law that governs Samsara is called Karma. Each birth and death we undergo is determined by the balance sheet of our Karma that is in accordance with the actions performed and the dispositions acquired in the past.

Karma: Action and its Consequences

Karma is a crucial concept. According to the doctrine of Karma, our present condition in life is the consequence of the actions of our previous lives. The choices we have made in the past directly affect our condition in this life. The choices we make today, and thereafter, will have consequences for our future lives. According to these teachings, a sound choice (using correct mixture of Satvic, Rajsic, and Tamsic attributes) can lead an individual towards making the right choices, committing the right deeds, thinking the right thoughts,

and having the right desires without the need for external commandments. Such actions also harmonize the decisions to serve the collective interests of family, society and the world at large. God has given us all freedom to act on our own, but he has not given up accountability. Good deeds are rewarded and bad deeds are punished. This creates responsible human conduct, serving the will of God.

Stages of Life

Sanatan Dharma recognizes two main lifelong Dharmas. Grihastha Dharma is applicable when we lead a family life. This applies to most of us. In this mode, four major goals are considered noble:

- Kama—the sensual pleasure and enjoyment while supporting procreation
- Artha—the worldly prosperity and success
- Dharma—the following of the laws and rules that an individual lives under
- Moksha—the liberation from the cycle of Samsara

Among these Dharma and Moksha play a key role. Dharma must dominate an individual's pursuit of Kama and Artha while seeing Moksha at the horizon.

Sannyasin Dharma recognizes, but renounces, Kama, Artha, and Dharma, focusing entirely on Moksha. A Grihasthi might choose to enter Sannyasin Dharma.

Moksha is when a person is freed from the cycle of birth and rebirth. When an individual attains eventual union with Brahman, Moksha is achieved. This union can be achieved through *Gyana* (true knowledge) or *Bhakti* (devotion).

Purity, self control, truthfulness, non-violence, and compassion towards all forms of life are the necessary pre-requisite for any spiritual path.

I studied at Sanatan Dharam High School for five years. Every day we started with the recitation of the Bhagavad Gita. Every two weeks there was a recitation of the Ramayana to the entire school. We devoted one of our eight periods to the recitation of stories from Puranas or other stories that stressed high moral life. They illustrated the duties of a student, son, or father, generally as brother or member of the family. In this sense it reminded me of the legacy of gurukul in a modern age.

In observing Sanatan Dharam families, these people were leading a normal life in society. They were not excessively materialistic. They displayed spiritual tenor in their dealings. They were knowledgeable, considerate, and reflective.

They treated the Vedas and Upanishads as the sacred legacy of mankind.

Several of my classmates excelled in life, becoming role models in society.

They believed in only one God and did not subscribe to the Gods of Christians, Muslims, Hindus, Buddhists, Jains, and Sikhs etc. as being different. They subscribed to the Rig Veda statement saying *"You can call it by many names, but there is only one God. Our Creator."*

In certain times, each person went through some ceremonies such as a children coming of age, marriages, and deaths. The ceremonies that were performed included the recitation of hymns from the Vedas that were written for the purpose. The idea is to keep instilling spiritual tenor into the otherwise materialistically-oriented life.

The statue worship, which is part of the Hindu Religion which is a modern day version of Sanatan Dharma, (so named by the Muslim invaders) is sadly misunderstood.

A temple is a place for social gathering, as well as a place to worship. The many God's and deities that are worshiped include the three manifestations of God which are Brahman, Vishnu, Shiva, and their consorts in the form of Goddesses.

The most popular Goddesses include Saraswati, Lakshmi, and Parvati. Saraswati is the wife of Brahman and is also known as the Goddess of knowledge and wisdom. Lakshmi is the wife of Vishnu and is also known as the Goddess of wealth. Parvati is the wife of Shiva and is also known as the Goddess of household and motherhood.

Some temples include Lord Rama and Lord Krishna manifestations of Lord Vishnu. Worship of Hanuman, a devotee of Lord Rama, is also practiced in his own right.

Lord Ganesha is the son of Lord Shiva and is greatly revered. His idols are found everywhere in homes, with the hope of bringing good fortune to believers. *Make no mistake that all devotees understand that there is only one God, the creator of us all.*

Typical Practices

Worship is integral part of daily life. It could be as simple as the Aarti—a recitation of a poem in the praise of God. A household temple could located in any corner of a house with a picture of any one of the God forms whether it is Brahman, Vishnu, Shiva, Krishna, Ram, etc. Some people include founders of other faiths such as Guru Nanak, Jesus Christ, etc. *Cremation* means the dead are burnt not buried.

Pilgrimage is an important aspect of life. It is not required, but it is desirable to visit certain holy places such as the Ganges river or some temples that have acquired iconic status. Thus, sacred sites include rivers, temples, mountains, and other sites in India. These are sites where the Gods may have appeared or became manifest in the world.

All Sanatan Dharma devotees believe in reincarnation and the three fold path of knowledge, meditation, devotion, and good works. (Righteous Karma).

Everyone believes in a living God that is to be experienced through good Karma and sincere meditation, not through faith alone.

CRADLE OF CIVILIZATION

There is no civilization on planet earth that has continuous record of its achievements as does the Indian Civilization. Much of its prehistory is recorded in the Puranas, the Vedas, the Upanishads, and its remarkable epics of Ramayana and Mahabharata. The prehistory is remarkable in its poetic content, outstanding in its clarity of language, and superb in the details of the contents that are provided.

The destruction of Indian universities, scholars, and other elements of culture by invading Muslim armies literally destroyed all traces of Indian history. Many scholars fled to Nepal, Sri Lanka, and Burma with notable documents of prehistory. The history of India was reconstructed during the British colonial rule. The many scholars assembled by the British did a remarkable job of translating the available material and planted some biases that literally destroyed India's claim to antiquity.

Greece and Egypt faced a similar tragedy when their history and cultural treasures were destroyed by Romans, Christians, and later by Muslim invaders.

Until recently, Egypt was still considered to be the oldest civilization, because the Pyramids were believed to be only visible evidence of any lost civilization. This will now change due to radical discoveries coming to fore. All Egyptian Pharaoh's were wrapped in Indian muslin. The textile industry

of India was fore runner of all known efforts in this area. The Worship of the Sun God and the temple of Konark prove that Indian influence had reached Egypt. Engravings of Vedic Hymns have been discovered in a few Pyramids. This adds to other supporting material that shows Indian influence in antiquity including Egypt.

There was a great deal of detail in the Rig Veda, Ramayana, Mahabharata, and Puranas that was about people, places, cities, and rulers of that period. All this was deemed as mythology.

The early scholars like Max Muller, whose team translated the Vedas and Upanishads formulated an Aryan invasion theory and placed the start of the Indian civilization to around 3500BC.

The Aryan invasion theory produced many Ideologists who devoted considerable time tracing the origin of Indo European languages and their peoples.

This theory is now in disrepute as the basis has been challenged. Mounted evidence has been provided by recent Indian, American, and other scholastic efforts.

The British team, lead by Burton, undertook the search for the beginning of the Nile river. They failed. A later effort, by Capt Speake, was successful. He credited his success to information he found in the Puranas. Suddenly, many scientists started to give a second look to Indian literature that spoke of life in prehistory.

Spiritualistic knowledge is everywhere in India

*Materialistic knowledge and the wonders
that were left behind by ancient Inaida
are starting to get exhumed. Architectural
diggings started less than one hundred
years ago.*

In ancient India, progress of society occurred much earlier than any other known civilization. The validation of this far-reaching statement would have been unthinkable just one hundred years ago. Egypt was the only places where humans left visible landmarks behind called pyramids. The last hundred years have changed all this. I will mention three big recent discoveries in relation to ancient India thanks to NASA and ISRO satellites, as these are truly far-reaching in their impact.

The first excavation occurred during British rule, prior to partition of India, in Harappa and Mohenjo-Daro, Mehrgarh. (today's Pakistan) They have now been followed by nearly 2400 excavations. Almost 1,200 of them were around the Legendary Saraswati River which now flows underground, but was a mighty navigable river in its antiquity.

These excavations show that these settlements, no matter how big or small, had sophisticated irrigation, drainage, and sewerage. Sophisticated irrigation and water storage systems were developed by the Indus Valley Civilization which included artificial reservoirs.

A system of standardization, using weights and measures, was made evident by excavations at Indus Valley sites. This

technical standardization enabled gauging devices to be used effectively in angular measurements and measurements in construction. Calibration was also found in measuring devices along with multi subdivisions in the case of devices.

The world's first dock at Lothal, in 2400BC, was located away from the main current to avoid the deposition of silt. This was the earliest known dock found in the world equipped to berth and service ships. All this early information supported seafaring skills and trade with the then known world.

Evacuations near Balakot, in 2500-1900BC, (today's Pakistan) show evidence of an early furnace for manufacturing ceramic objects. Ovens dating back to civilization's mature phase in 2500BC-1900BC were also excavated.

The use of large scale constructional plans, cosmological drawings, and cartographic material was known according to University of Minnesota. A number of surveying instruments were also found at these sites. Other archeological evidence showed animal-drawn ploughs and swords dating back to 2300BC.

In Yajurveda, numbers as high as 10^{12} were included in texts during 1200-900BC. A capability to count trillions that early is nothing short of remarkable. By 800AD, Indian mathematicians could count to 10^{56}. No other civilization can make this claim. In the Vedic Sutras one can find examples of advanced algebra and geometry.

Indians observed the planetary movements and calculated the speed of the Earth, Sun, etc. It calculated the diameter of Earth, value of Pi that is even today the most accurate known values. Astrology was developed so that the movement of planets could be accurately predicted and their interaction

was well understood. Astrology was routinely used to predict solar and lunar eclipses. It was also used to pick favorable times to plant crops. Twelve signs of zodiac and twenty-seven constellations along with seven planets were known. Cotton and Silk industries were advanced. The trade made it possible to develop the concepts of positive and negative numbers.

The recent excavations such as Dwarka, that discovered the sunken city of Lord Krishna, will throw light at remarkable construction techniques. Dwarka was known to be the Golden City of palaces and temples. The survival of this city, under the Arabian Sea for almost 12000 years, is a notable accomplishment.

Indian Sages divided life into four Yugas:

- Sat Yuga
- Treta Yuga
- Dwapara Yuga
- Kali Yuga

The Ramayana epic describes the life and times of Lord Ram during Treta Yuga. Similarly, the Mahabharata describes the life and times of Lord Krishna which occurred in the Dwapara Yuga era. We are believed to be in Kali Yuga now. It is believed that Kali Yuga started at the end of the Battle of Mahabharata.

These facts are known to Hindus who read these sacred books on a daily basis. Three things stand out about Ancient India:

- The battle of Ram against Ravan who was the demon king of Sri Lanka. Every year the festival of Dewali is

celebrated to commemorate the victory of good over evil as Ram won.

- The Battle of Mahabharata was fought between righteous Pandavas and evil Kauravas. Again, good won over evil, as Pandavas won.

- Bhagwat Gita, one of the best known treatises on rightful action and rightful life, was a record of conversation between Arjuna and Lord Krishna. Bhagwat Gita invokes the Vedas and stresses the divine knowledge of the Vedas. The Vedas were revealed knowledge that was passed on to seven legendary Rishi's. Next, it was passed on orally to other Rishi's. These Rishi's passed it on to the masses that took this tradition seriously, and kept the revealed knowledge intact.

The earlier Rishi's associated with the Vedas, and many of the early Sage's lived around the great Saraswati river. No such river exists in India today, so it fueled to strengthen the bias that all narratives have no historical validity.

At the end of the Mahabharata, as lord Krishna returned to Dwarka, he summoned Arjuna to move Lord Krishna's family as the legendary town of Dwarka was about to sink into the ocean. Arjuna rescued all those that lord Krishna wanted, and then he observed Dwarka as it sank underwater. A detailed description was provided in the Mahabharata.

For over two hundred years, as the British ruled India, no effort was made to substantiate any Indian claims for the fear it might upset the apple cart. The independence of India in 1947 changed that.

The only excavation of note, until now, was made by Sir John Wheeler who discovered Harappa and Mohenjo-Daro. These were Dravidian cities. They were the most advanced cities ever dug up. It claimed that these cities could have been overrun by the invading Aryans. Since that time, more excavations were made that are similar. The excavations in the vicinity of the Indus were used to strengthen the Aryan invasion theory.

The mighty Saraswati river was described in prehistory to be miles wide, carrying commerce from Ayodhya to the Arabian Sea, just south of Indus River. It went underground thousands of years ago, and had disappeared for all practical purposes of the peoples. It was described by proponents of the Aryan invasion theory as mythological.

Two things happened in this recent period. A considerable number of Indian scientists had acquired knowledge, second to none, and were educated in England. (Oxford, Cambridge, and reputable American universities) Clearly, their findings could stand the test of time, as they were using leading edge of technology and tools to substantiate their claims.

The second thing that occurred to the benefit of mankind was NASA's space exploration program. India joined the Space exploration. The ISRO is India's NASA in its own right. Its discoveries are turning heads. For example, the discovery of water on the moon was first discovered by ISRO satellites. A remarkable set of events now took place due to these efforts of NASA and ISRO.

- NASA provided pictures of the bridge between India and Sri Lanka that was said to have been built by Sri Ram prior to battle with king of Sri Lanka. It was

reputed to have been built during the Treta Yuga and thousands of years ago. The bridge's unique curvature and composition by age reveals that it is manmade. The legends as well as archeological studies reveal that the first signs of human inhabitants in Sri Lanka date back to primitive age thousands of years ago. Bridge age may almost be equivalent. This information is a crucial aspect for an insight into mysterious legend called the Ramayana. The Ramayana is supposed to have occurred in Treta Yuga. The validation of the existence of a bridge is the tip of an iceberg. The Ramayana also talks about space travel and vimanas. (flying chariots) A treatise on the design of ancient vimana is now available for sale in reputable book stores such as Barnes and Noble. This is not only history of planet Earth, but it is the history of this universe.

- The second discovery by **NASA** and **ISRO** was equally astounding. They discovered the missing and mighty Saraswati river that went underground some 8000 years ago. The isotopic study of ground water in Jaisalmer and Ganganagar districts of Rajasthan, by Nair and Rao, has concluded that shallow ground water was some 2000 to 6000 years old. Furthermore, it concluded deep seated water was some 6000 to 12000 years old. R.V. Athavale of the National Geophysical Research Institute has culled evidence of twelve earthquakes from archaeological and geo-morphological records on evacuated Vedic sites. Subsequent to one or more of these earthquakes, the Sutlej river shifted west, becoming an Indus tributary. The Yamuna river moved

east, joining the Ganges river later on. Recently, close to 1200 excavations have been completed in the vicinity of the original Saraswati's banks, where all the reputed Rishis lived. It is ironic that all the places, where Rishi's heritages were mentioned in the Ramayana, have now been found. The excavation in the Indus and Saraswati basins now strongly prove Indo Saraswati civilization claims for their place in antiquity. (around 12,000BC or Vedic era)

- The third event took place when Dr. Rao of the Archeological Survey of India was called in to observe the demolition of some temples in Dwarka. These temples were obstructing the view of pilgrims that visited Dwarka yearly as the most sacred place of pilgrimage. As demolition started, they discovered another temple underneath the temple, then yet another temple underneath the second one. Ultimately, they reached the sea level where they discovered some human objects that dated some 12000 years old. Dr. Tripathi indicated that their finds included copper coins, terracotta animal figurines, sculptural and archaeological fragments, bangles made of shell, bone and glass, beads of stone and terracotta, rings, stone objects, and a variety of plain and decorated pottery, both painted and incised.

The search for the sunken city of Dwarka had begun. Only a few years later they found Dwarka about 120 feet below sea level. They found the legendry walled city of Dwarka with its many palaces, temples, and unlimited wealth. It was the city

that Lord Krishna built which flourished for thousands of years.

The Archeological work that is going on, at slow pace, is entirely manned by Indian personnel. This city is believed to be some 30000 years old. These events have proven the validity of narratives in the Puranas, Ramayana, and the Mahabharata. It also proves that ancient Indian civilizations thrived for a long time before the great flood, or deluge that occurred around 30,000 BC.

The greatest beneficiary of all these findings is renewed interest in study of the Vedas and Upanishads. The material content of these sacred books is the greatest legacy of mankind.

Take for example consciousness, which was revealed in the Vedas and studied for thousands of years in ancient India. It was not mentioned in any books on religion such as the Old Testament, Bible, or Quran. Consciousness is described as the ultimate mystery in Indian texts, and its study is lauded as the highest science.

Recently, Dr Subhash Kak and TRN Rao provided an interesting discussion of this subject that indicates that the study of consciousness is acquiring center stage in modern science. They also point to intriguing parallels between the insights of the early Vedic theory of consciousness, and those of quantum mechanics and neuroscience.

Dr Deepak Chopra looks at consciousness from a religious and medical stand point. It is utterly amazing that breakthroughs of tomorrow were already discovered by Sages thousands of years ago. Now, modern science will find many new applications to apply this ancient knowledge.

The distorted human history has been intentional, and it will continue in throughout the future. There is no dearth of humans that seek knowledge and truth. The new discoveries are a testament to their commitment. A rediscovery of events in the last hundred years has been made possible by American universities. They were not influenced by the distortions brought about by the colonizers in recent history and others great empires that proceeded the modern era.

India Cradle of Civilization

Currently, many theories are floating around that describe how the populating of earth was accomplished. The weight of evidence is in favor of Indo-Malaysia.

The Polynesian or Island People researches show that their fore fathers were peoples of Indian origin that kept moving east until they settled in Malaysia, becoming sea faring. In addition, these researches indicate that their early Gods were also Indian Gods. This was also validated by the James Cook's expeditions.

It is now acknowledged that the same stock of Indo-Malaysian people travelled north and eventually found a land route to America, Central America, and even South America. For long time, Argentina peoples claimed their ancestral home was India and was so recorded in the Encyclopedia Britannica.

The westward migration of people of India swept through Persia, the Greek Islands, present day Syria, Iraq, and Egypt. This was recorded in the Genesis Eleven portion of the Bible

as an event after the deluge around **13000 BC**. The Bible cites the movement of people from east to west, but it does not cite the timing. It also states that at this time there was only one language throughout the world. The scientists have pegged the time of the deluge to be during this period.

Smithsonian published three articles that show the relationship of people by archeology, **DNA**, and Language. It also established the relationship of all Indo-European peoples and recognized Sanskrit as their possible mother language. An imaging feature of one of these articles was a map that showed that people throughout history have moved from Africa towards Asia, from Asia towards Africa, and from Asia going east, then north. This explains why so many theories prevailed.

The Indo-Malaysia theory has significant data to support it. The Encyclopedia Britannica states that *if there is any country on earth which can justly claim the honor of having been the cradle of human race, the successive developments of which were carried into all parts of the ancient world, and even beyond, the blessings of knowledge which is the second life of man, that country is assuredly India.*

Will Durant, an eminent philosopher and historian wrote that *India was the motherland of our race and Sanskrit is the mother of Europe's languages. She was mother of our philosophies, mother through the Arabs of much of our mathematics, mother through Buddha of the ideal embodied in Christianity, mother through the village communities of self government and democracy. Mother India is, in many ways, the mother of us all.*

Lin Yutang, a well known Chinese writer, says in the book called Wisdom of India that *India was China's teacher in religion, and imaginative literature, and world's teacher in Trigonometry, quadratic equations, grammar, phonetics, Arabian Nights, Animal Fables, Chess as well as philosophy and she inspired Boccaccio, Goethe, Schopenhauer and Emerson.*

The Indian claim, to be the oldest and mother of civilizations, is further strengthened by not only being first on the planet earth, or by populating the known ancient world, but by contributing its knowledge to the entire known world at that time.

Science, Medicine, and Technology in ancient India

In the first chapter, the spread of Indian knowledge was briefly described. The struggle of this knowledge was in Greece at the hands of Romans, the early Christian Roman Empire, Muslim invaders, Genghis Khan, Hulagu Khan, and later Muslim Invaders of India was also discussed.

An impression may have been left is that it was knowledge of mathematics or spiritualistic knowledge alone that was passed on and suffered. To correct this impression, a brief out line of Indian science, medicine, and technology for that period is provided.

Science, Medicine, and Technology

Science and technology in ancient and medieval India covered all the major branches of human knowledge and activities including mathematics, astronomy, physics, chemistry, medical science, surgery, fine arts, mechanical and production technology, civil engineering, architecture, ship building, navigation, sports, and games.

Ancient India was a land of Sages, Saints, and Seers as well as a land of scholars and scientists. Ancient India's contribution to science and technology includes many fields.

Vedic literature is replete with the mathematical concept of zero, the techniques of algebra, and mathematics. As an example, a recent publication of a book which shows the translation of sixteen Vedic Sutra's by Jagadguru swami Sri Bharati Krsna Tirthaji Maharaja, shows knowledge pertaining to multiplication, division, factorization of simple and complex quadratics, factorization of cubic's, simultaneous equations, quadratic equations, cubic equations, multiple simultaneous equations, multiple simultaneous equations, factorization and differential calculus, partial fractions, integration by partial fractions, Vedic numerical code, reoccurring decimals, straight division, auxiliary fractions, divisibility and simple oscillators, divisibility, and multiplex oscillators, sums, difference of squares, elementary squaring, cubing square root, cube root, Pythagoras theorem, Apollonius theorem, and analytical conics.

My initial degrees were in mathematics and physics, prior to my undertaking of engineering at basic, graduate, and

advanced levels. This material convinces me that ancient Indians were indeed millenniums ahead of the mankind.

Arguably, the origins of calculus lie in India three hundred years prior to Leibnitz and Newton.

In the course of developing a precise mapping of the lunar eclipse, Aryabhatta was obliged to introduce the concept of infinitesimals to designate infinitesimal, or near instantaneous motion of the moon, and express it in the form of a basic differential equation. Aryabhatta's equations were elaborated on by Manjula (10th century) and Bhaskaracharya (12th century) who derived the differential of the sine function. Later, mathematicians used their intuitive understanding of integration in deriving the areas of curved surfaces and volumes enclosed by them.

Astronomy

The **Rig Veda** refers to Astronomy. India had made considerable advances in astronomy and made active use of it in support of religious ceremonies. It was also used to predict weather in support of farming. The prediction of lunar and solar eclipses was a direct result of this knowledge. Indians were the first to understand that our solar system rotates around the Sun. They calculated the speed of the motions of various stars. They also calculated the diameter of the Moon, Earth, and more. These are still accurate thousands of year later. An entire Vedanga called Jyotisa was written during the Vedic period. Astronomy continued to advance and retained its leadership up until the 16th century. Now it found the

patronage of Akbar the Great who commissioned the building of the Jantar Mantar Observatory in several cities in India. (Including Delhi, Jaipur, etc.)

A direct result of this was astrology, which was used by sages to pick appropriate times for planting crops, coronation of kings, or marriages of people.

Chemistry and Physics

Concepts of the Atom and Theory of Relativity were explicitly stated by an Indian philosopher around 600 BC. The root to the concept of the Atom in ancient India is derived from classification of the materialistic world in five basic elements by ancient Indian philosophers. These five elements' classifications existed since Vedic times around 13000BC or earlier. These five elements were Earth, Fire, Water, Air, and Ether or Space. These elements were also associated with human sensory perceptions for example; Earth is associated with smell, air with feeling, fire with vision, water with taste, and ether or space with sound. Later, Buddhist philosophers replaced ether or space with life, joy, and sorrow.

From ancient times, Indian philosophers believed that, except ether or space, all other elements were physically palpable and hence comprised of small and minuscule particulars of matter. They believed that the smallest particle which could not be broken down any further was called the paramanu or atom. It is a Sanskrit word. Param means ultimate or beyond, and Anu means Atom. Thus, paramanu literally means beyond atom. This was a concept, at an abstract level,

which indicated the possibility of a splitting atom. This is now the source of atomic energy.

Kanada, a 6th century Indian philosopher, was the first person who went deep systematically in such theorization. Another Indian philosopher named Pakudha Kaccayana, who was a contemporary of Buddha, also propounded the ideas about atomic constitution of the materialistic world. All these were based on logic and philosophy, lacking an empirical basis. Similarly, the principle of relativity, not to be confused with Einstein's theory of relativity, was available in an embryonic form in the Indian philosophical concept of samikshavad. The literal translation of this Sanskrit word is theory of relativity. These theories have attracted attention of the ideologists, and the Australian veteran A. L. Basham has concluded that they were brilliant imaginative explanations of the physical structure of the world. In large measure, he agreed with the discoveries of modern world.

Chemistry

Ancient India's development in chemistry was not confined to an abstract level like Physics, but India found development in a variety of practical activities. In early civilization, metallurgy has remained an activity central to all civilizations from the Bronze Age to the Iron Age, and to all other civilizations that followed. It is believed that the basic idea of smelting reached ancient India from Mesopotamia and the near east. Coinage dating from the 8th century BC to the 17th century AD

indicates numismatic evidence of advances made by smelting technology in ancient India.

In the 5ᵗʰ century **BC,** the Greek historian Herodotus observed that the Indian and Persian army used arrows tipped with iron. Ancient Romans were using armor and cutlery made of Indian iron.

In India, certain objects testify to higher level of metallurgy achieved by the ancient Indians. By the side of **Qutub Minar,** a world heritage site in New Delhi stands an iron pillar which is believed to be cast in the Gupta period around **500AD.** The pillar is **7.32** meters tall, tapering from diameter of **40** cm at the base to **30cm** at the top, and is estimated to weigh six tons. It has been standing in the open for last **1500** years withstanding wind, heat, and weather, but still has not rusted. This kind of rust proof iron was not possible until iron and steel was discovered a few decades ago.

The advanced nature of ancient India's chemical science also finds expression in other fields like the distillation of perfumes and fragment ointments, manufacturing of dyes and chemicals, polishing of mirrors, and the preparation of pigments and colors. Paintings found on the walls of Ajanta and Ellora, which are both world heritage sites which look fresh even after **1000** years, also testify to the high level of chemical science achieved in ancient India.

Medical Science and Surgery

Near **800 BC,** the first compendium on medicine and Surgery was compiled in ancient India. Ayurveda is a science

of medicine that has its origin in ancient India. Ayurveda consists of two Sanskrit words—Ayur means age or life and Veda means knowledge. Thus, the literal meaning of ayurveda is the science of life and longevity. Ayurveda constitutes ideas about ailments, diseases, their symptoms, diagnosis, and cures. It relies heavily on herbal medicines including extracts of several plants of medicinal values. This reliance on herbs differentiates ayurveda from systems like allopathy and homeopathy. Ayurveda has always disassociated itself with witch doctors and voodoo.

Ancient scholars of India such as Atreya and Agnivesa have dealt with principles of ayurveda as long back as 800 BC. Their works and other developments were consolidated by Charaka who compiled a compendium of ayurvedic principles and practices in his treatise called the Charaka-Samahita. It remained like a standard textbook almost for two thousand years and was translated into many languages including Arabic and Latin. Charaka-Samahita deals with a variety of matters covering physiology, etiology, embryology, concepts of digestion, metabolism, and immunity. Preliminary concepts of genetics also find mention for example, Charaka has theorized blindness from the birth is not due to any defect in the mother or father, but owes its origin in the ovum and the sperm.

In ancient India, several advances were also made in the field of medical surgery. Specifically, these advances included areas like plastic surgery, extraction of cataracts, and even dental surgery. Roots to the ancient Indian surgery go back to 800 BC. Sushruta was a medical theoretician and practitioner. He lived 2000 years before in the ancient city of Kasi which is

now called Varanasi. He wrote a medical compendium called Shushruta-Samahita. This ancient medical compendium describes at least seven branches of surgery. They are excision, scarification, puncturing, exploration, extraction, evacuation, and suturing. The compendium also deals with matters like rhinoplasty which is plastic surgery, and ophthalmology which is the ejection of cataracts. The compendium also focuses on the study of human anatomy by using a dead body.

In ancient India, medical science supposedly made many advances. Specifically, these advances were in the fields of plastic surgery, extraction of cataracts, and dental surgery. There is documentary evidence to prove the existence of these practices.

Yoga was also an Indian discovery and has several aspects. One of its branches is also a system of exercise for physical and mental nourishment. The origins of yoga are shrouded in antiquity and mystery. Since Vedic times, thousands of years before, the principles and practice of yoga had crystallized. It was only 200 BC when all the fundamentals of yoga were collected by Patanjali in his treatise named Yogasutra that is Yoga-Aphorisms. Patanjali surmised that, through the practice of yoga, the energy latent within the human body may be made alive and released which has salubrious effects on the body and the mind. Now, in modern times, clinical practices have established that several ailments including hypertension, clinical depression, amnesia, and acidity, can be controlled and managed by yogic practices. The application of yoga in physiotherapy is also gaining ground.

Civil Engineering and Architecture

Much of ancient India's urban civilization lies buried, awaiting discovery. The discovery of the sunken city Dwarka has already achieved the recognition of Archeologists around the world. The discovery of Mohenjo-Daro and Harappa brought to fore Indian genius and placed it on par or beyond Egypt.

These townships were examples of city-planning before 5000 BC. From that point on or even earlier, ancient Indian architecture and civil engineering continued to develop and grow. It found manifestation in the construction of temples, palaces, and forts across the Indian peninsula and neighboring regions. In ancient India, architecture and civil engineering were known as sthapatya-kala. That was the literal translation that means the art of constructing.

During the period of the Kushan and Maurya Empires, the Indian architecture and civil engineering reached to regions like Baluchistan and Afghanistan. Statues of Buddha were cut out, covering entire mountain faces and cliffs. An example is the Buddha's of Bamiyan, Afghanistan. Over a period of time, ancient Indian art consisted of construction blended with Greek styles. It spread to Central Asia.

On the other side, Buddhism took the Indian style of architecture and civil engineering to countries like Sri Lanka, Indonesia, Malaysia, Vietnam, Laos, Cambodia, Thailand, Burma, China, Korea, and Japan. Angkor Wat is a living testimony to the contribution of Indian civil engineering and architecture to the Cambodian Khmer heritage in the field of architecture and civil engineering.

In mainland India today, there are several marvels of ancient India's architectural heritage including world heritage sites like Ajanta, Ellora, Khajuraho, Mahabodhi Temple, Ranchi, Brihadisvara Temple, and Mahabalipuram.

Mechanical and production technology of ancient India ensured the processing of natural produce and their conversion into merchandise for trade, commerce, and export. A number of travelers and historians including Megasthanes, Ptolemy, Faxian, Xuan'Zang, Marco Polo, Al Baruni, and Abu Batuta have indicated a variety of items which were produced, consumed, and exported around that society's known world by the ancient Indians.

Ship Building and Navigation

A panel found in Mohenjo-Daro depicts a sailing craft. Thousands of years later, Ajanta murals also depicted a sea-faring ship. The science of shipbuilding and navigation was well known to ancient Indians. Sanskrit and Pali texts are replete with maritime references. Ancient Indians, particularly from the coastal regions, were having commercial relations with several countries across the Bay of Bengal. Such countries included Cambodia, Java, Sumatra, Borneo, and even China. Similar maritime and trade relations existed with countries across the Arabian Sea like Arabia, Egypt, and Persia.

Even around 500AD, sextants and mariner's compasses were not unknown to ancient Indian shipbuilders and navigators. J. L. Reid, a member of the Institute of Naval Architects and Shipbuilders in England, was published in the

Bombay Gazetteer at the beginning of the 20th century. The early Hindu astrologers are said to have used the magnet, in fixing the North and East, in laying foundations and other religious ceremonies. The Hindu compass was an iron fish that floated in a vessel of oil and pointed to the North. The fact of this older Hindu compass seems placed beyond doubt by the Sanskrit word maccha yantra, or fish machine, which Molesworth gives as a name for the mariner compass.

PROTECTION

(Of Knowledge and Human Heritage)

When God revealed knowledge to humans through the Vedas in Ancient India, it was probably the only civilization on planet earth. The languages were not developed and the writing came much later. The seven Rishi's who were entrusted with revelation were literally the first humans on earth and were created by the will of God. They lived thousands of years as Sages until their mission of passing their knowledge to humans was completed. This involved passing this information to the learned Rishi's who set up gurukuls to preserve this. For thousands of years, it was memorized and passed down generation to generation. During this period, Devanagari was the common language. It became the predecessor of Sanskrit.

The knowledge was revealed in a cryptic and poetic form. Indians made it their highest priority to preserve it for later generations to come. The inquiry that the Vedas kicked off led to the Upanishads and the Gurukuls. This started a generation of dedicated Sages and scholars that generated a store house of materialistic and spiritualistic knowledge.

This knowledge was preserved with the zeal necessary. Even today, the cities that have been dug up by archeologists seem contemporary by any standard. The applied knowledge opened up many fields of endeavor.

As this knowledge was shared with the Persians, Greeks, and Egyptians a brotherhood of mankind was forged. The world started developing as per the will of God. When this knowledge was passed on to the third Caliph of Baghdad, it kicked off a wave of translation where a very large number of Indian books were translated to Arabic and Latin. These books contained knowledge in many fields. Some of the earlier translations into Greek were also translated. It is for this knowledge and its sharing that the world owes Ancient India its debt.

The early era of expanding empires tested the skills and strength of armies. The battles were fought honorably. Even armies of Alexander the Great documented the plants and crops that grew in different countries and collected the books of knowledge. He was so impressed with Taxila university that he set up the first university outside of India in Alexandria, Egypt.(city that Alexander the Great founded and named after himself) This university blossomed with Indian, Persian, and Greek scholars who contributed to the spread of knowledge.

As the time marched on, the Persians wanted to expand their influence. To do so, they attacked and captured Greece. These wars led to much destruction and the loss of life. History records the bravery of the three hundred Spartans that died defending to the last man. The naval battles were probably the first.

The influence of Persians reached as far as Egypt. The tide only turned when Alexander the Great attacked Persia after his victories in Egypt and in Asia Minor.

Persian armies were no match for the invasion of the Greek army. The Persian army lacked discipline and training. The glory of the great Darius Empire was gone.

Peace prevailed on the eastern border of Persia during this time. Even during Alexander's invasion of India, it hardly touched most of India. Seleucus, one of the generals of Alexander, won everything between Egypt and India, including Asia Minor. He returned with a much bigger army to attack India. India had undergone considerable restructuring under the leadership of the new king Chandragupta Maurya. Seleucus was handily defeated and surrendered all Indian Territory that was won by Alexander. Peace prevailed between the Greeks and Indians. Greek armies never returned.

India enjoyed a peaceful period for almost a thousand years. The growth of knowledge and prosperity of people was noticed worldwide. Indian ships were docking hundreds of ports. The merchandise the Indian ships carried reached the entire known world. One of the reasons for downfall of the Roman Empire was a huge balance of payments problem with India.

The Roman Empire was on the march and destroyed whatever was left of the Glory that was once Greece. It will never be a force to contend with again. The barbarians in the North became an eternal problem for Rome. Many battles were fought, until the Christian Roman Empire moved its Capital to Constantinople. After the move to Constantinople, the empire lasted for hundreds of years. The Christians were persecuted in Rome for promoting the kingdom of heaven. They claimed that all people are equal in the sight of God and that beauty, wealth, and power were only superficial. This

all changed when Christianity became the state religion of Rome. Immediately, intolerance of all other views became their hall mark. The Greeks that are credited with western culture became the first victim.

Their religion was declared as a Pagan religion and their temples were all destroyed as were many of the treatises that were devoted their knowledge. The pillars from these temples still clutter the landscape in Greece. Many of these pillars were hauled off to Constantinople. The Caesar who ruled in Constantinople wanted to build a road from Constantinople to Rome with these pillars on both sides. St. Sophia was the first church building that was built on the shoulders of these pillars. The great Cistern of Constantinople is supported on these pillars. One of the notable female Greek Goddesses adorned one of these pillars at the top. Now in the Cistern, this pillar with her head buried into the ground displays the Christian disrespect for Greek Gods and Goddesses.

The Christian state authorized the destruction of scholars, the destruction of the University at Alexandria, and the destruction of the university's library which was the largest library during the time period. All these actions point out that there was total insensitivity to other cultures and religions.

When Islam rose, their foundations were also laid on others' bloodshed. The sword of Islam did not spare anything in its way.

Now the two forces of Christianity, in Europe, and Islam, in the Middle East, were both on the move. Each claimed that their religion was the only true religion. Islam claimed that it was their birth right to conquer the world. In the name of Allah, Muslim armies captured large areas of the land throughout

the Middle East. The onslaught into North Africa and Spain was underway. The confrontation between Christians and Muslims had to occur.

Europe was primarily Christian. Religion and church were omnipresent. The church's influence made the different kings irrelevant. The greatest threat to the existence of Europe seemed to be militant Islam which had invaded Spain, but was stopped at the Battle of Tours in 732 AD.

The church acted as the agency of Christ-the intermediary between God and people. It was believed that church alone possessed the means of salvation. The church gave to people the sacraments by which they could gain God's grace-baptism, confirmation, the mass, and penance. It gave priests the power that the common man did not have. It brutally enforced the church dictates. They punished those opposing and excommunicated individuals or groups.

Finally, in the eleventh century, Europe decided to attack after the Seljuk Turks occupied the Middle East, conquered the Holy Land, and furthermore endangered Constantinople.

The first Crusade took place in 1095AD. It was a military success. Asia Minor was conquered in 1097AD, and Jerusalem fell in 1099AD. Several more Crudes took place, but they were not nearly as successful. The Christendom was on the move elsewhere. They had captured Sicily from the Moors and regained most of the peninsula. The trouble from the Ottoman Empire was still ahead, but Europe had proved itself to be capable of defending itself.

In 1216AD, Genghis Khan and 60,000 barbarians invaded the Middle East. They destroyed the cultural centers, the irrigation works, and laid waste to the land. In 1253AD, the

second wave of Mongols led by Hulagu Khan invaded. It destroyed 800,000 people in just one week. Arab savagery had broken against greater savagery of Mongols. The sword of Islam bowed before the more merciless sword of Halagu. Never again would Mohammedans regard themselves with complete conviction as possessors of God given right to rule the world. The evidence of their failure was all around in the ruins of three empires. In 1260AD, the observers in Cairo would have very little to suggest that Islam had the strength to survive. The glory days of Islam were behind them. Kaaba in Mecca still rallied the faithful.

In India, Arab invasion took place early in the seventh century. (712AD) The second wave was Turkish-Mongol invasions and finally, the conquest by the Moguls.

During the first invasion by Mohd bin Qasim, peaceful life followed a relatively easy victory. Then, the church reviewed the victory as unsatisfactory and ordered the wholesale murder of all except women and children. (Many of them were taken away as slaves)

The second wave that started with Tamerlane resulted in much bloodshed and violence. When Tamerlane led his armies into India, his stated purpose was to give booty to his solders and bring Indians under Muhammadan yoke.

Subsequent invasions repeated much bloodshed, the destruction of universities, the destruction of libraries, the destruction many great temples, and the destruction of the infrastructure of India. India plunged into the Dark Age.

Mogul invasion of Babar produced limited loss of life. The destruction from the time of Akbar the Great, a relative peace

and order was restored. India now started to recover. When Akbar's great grandson Aurangzeb took the throne, he decided that all infidels would be eliminated. It was either conversion to Islam or death. Many lives were lost in this period and India was never the same again. The Mogul empire collapsed soon after. India was now ruled by many small fiefdoms. The East India Company that had arrived to set up trading posts took advantage of internal dissention and corruption of this period which had hundreds of years of intrigues. Many areas were taken over by the company. When the 1857 rebellion failed, it led to the British rule.

With this brief review of history, which is very brief and sketchy, it is hard to blame the individual on whether these were Christians or Muslims. The lust for power in the name of God or just the lust for powers sake seems to be the culprit. Not all invaders or conquerors were brutal destroyers of knowledge or the loss of life.

History can judge the brutal and unjust Caesars Tamerlane, Genghis Khan, and Halagu Khans. We hope that such history does not repeat itself.

The British colonial period had its ugly stories. India and China, who represented seventy-five percent of the entire world's GDP, were reduced to five percent leaving behind utter poverty.

World War I and II were not fought for the well being of any people, but to protect their own agendas. The Germans and Japanese came out with the short end of the stick.

Protection of Knowledge and the Human Heritage

Since times immemorial, it has been recognized that power in the good hands, is capable of doing considerable good. When the society is rich in good values, their leaders invariably act responsibly and serve to the interests of the people. Power in evil hands brings about immense destruction, the loss of life, the loss of property, and the loss of irreplaceable knowledge.

In Ancient India the society placed great deal of emphasis on balanced education both materialistically and spiritually. People knew the difference between good, bad, right, and wrong. Their government was democratic and the rulers truly served the people.

Religion was not abused for arousing people against each other. Religion and government do not mix. The history of Europe shows how people suffer when church edicts raise havoc with human rights. People could not practice their religion and all the bloodshed by the church led to many leaving for Americas. Here they ultimately formed the government of the people-by the people and for the people

After World War I, an attempt was made to end wars forever. The League of Nations that was formed, was not very successful and was unable prevent World War II. After this ended, another attempt was made to start a world body to prevent future wars and resolve many causes of conflict. The United Nations began in 1946.

Today, one hundred and ninety three countries are represented in the United Nations general assembly. It guides many agencies through its secretariat which is headed by the secretary general. The Security Council is vested with powers allowing them to direct countries to end wars, direct the end of atrocities against people or states, and direct the exercise of sanctions if its resolutions are not complied with. The many arms of the United Nations include:

- The world bank
- The international monitory fund
- The world health organization
- The food and agriculture organization
- The United Nations economic and social council organization
- The international atomic energy agency
- Several others such as International Court At Hague, and the Trusteeship council

The United Nations was well conceived but it is a weak organization. The reasons for its weakness include the lack of funding and the lack of proper representation.

The permanent veto power-holding members are allied powers of World War II. (USA, UK, Russia, France, and China) India with over a billion people, the third largest economy, and the largest democracy in the world, has no veto or regular membership in the Security Council. Tiny countries of Europe such as France and the UK are no longer relevant considering the new world order.

With all its weakness, it is still the only organization that provides the hope for a peaceful world. Nearly seventy-five percent of the funding is provided by only ten countries with the United States of America being its largest contributor at twenty-two percent.

UNESCO, a major arm of the United Nations that promotes economic and social co-operation has done considerable good. It has taken up the challenge of human rights and cultural diversity. A charter for the protection of human rights is developed. It binds all member states to protect human rights and the rights of minorities.

It still does not have sufficient strength to prevent things from happening such as the destruction of Buddha's by the Taliban Regime. However, it has identified many world heritage sites and increased awareness of the legacy of mankind.

The world is heavily leaning towards the Western form of education. Some of its flaws are coming into view. The emphasis on spiritual values is lacking, and the material values are over-emphasized. This imbalance is creating a major set of social problems.

The traditional knowledge, that has stood the test of time, needs additional support to ensure well being of the human race.

The current university system, and its allied library system, offers much greater protection against the heavy handed acts of dictators and destructive forces such as the Nazis in World War II.

The awareness of our spiritual legacy and its protection needs additional support through UNESCO and other government bodies across the world. Universities in the United

States of America have shown interest and have set up chairs to support Sanskrit, Indian Classical Music, and so on.

Knowledge, its pursuit, and protection are the highest obligation of mankind. Both lower and higher knowledge are needed to lead a balanced life.

REFERENCES

Bharati, Krishna Tirtha, and Vasudeva Sharana. Agrawala. *Vedic Mathematics*. Delphi: Motilal Banarsidass, 1992. Print.

Ellis, William, and Edouard R. L. Doty. *Polynesian Researches*. Rutland, Vt. [etc.: Tuttle, 1969. Print.

Holy Bible: The New King James Version, Containing the Old and New Testaments. Nashville: T. Nelson, 1982. Print.

Mehta, Rohit. *The Call of the Upanishads*. Delhi: Motilal Banarsidass, 1970. Print.

Müller, F. Max. *The Upanishads: Part. 1*. Oxford: Clarendon, 1879. Print.

O'Flaherty, Wendy Doniger. *The Rig Veda: An Anthology*. Harmondsworth: Penguin, 1981. Print.

Payne, Robert, and Robert Payne. *The History of Islam*. New York: Dorset, 1990. Print.

Pickthall, Marmaduke William. *The Meaning of the Glorious Quran: Text and Explanatory Translation*. New York: Muslim World League, 1977. Print.

Smith, L. B., and J. R. Smith. *World History in Outline*. Woodbury, N.Y.: Barron's Educational Series, 1996. Print.

ACKNOWLEDGEMENT

First of all, I wish to acknowledge the early influences and efforts of my high school Dharma teachers Shri Shiv Shastri and Shri Sukhdev Shastri who imparted spiritual learning in my early childhood. I am also thankful to the vast library resources in American universities during my engineering studies because they kept my spiritual flame alight.

Another acknowledgement goes out to my dear wife who demonstrated, through her Karma, a positive transformation of our larger family. More recently, our Bhagvid Gita discussion group Vandana reinforced my thinking on the role of karma and meditation. I am particularly grateful to Acharya Asha Ghate Ji for her contribution during our Vandana discussion sessions. She enhanced my interest to seek answers to a multitude of questions. These inquiries led to the undertaking of this work.

Another thanks to Deitrich Gerlt. He prepared this manuscript for publication. He ensured all the details such as correct spelling, grammar, editing, formatting, and other associated chores including the insertion of pictures. He ultimately converted all the material into a book format. It was a huge task. Deitrich provided invaluable assistance, and without it my manuscript may have never become publication-ready.

I give thanks to all those who have touched my heart in any way or provided assistance in the work of this book or life in general.